A LITTLE BIT
OF HEAVEN

a timeless collection of
stories, quotes, hymns,
scriptures, and poems
revealing the mysteries
of heaven

RACINE, WI

A Little Bit of Heaven
ISBN: 979-8-88898-009-5 - *Paperback*
ISBN: 979-8-88898-010-1 - *Hardcover*
ISBN: 978-1-970103-42-7 - *Ebook*
Copyright © 2022 by Honor Books
Racine, WI

Cover design by Faille Schmitz

INTRODUCTION

Is this life all there is?

Through the ages, many people have dared to believe for—a life after life—an eternity of bliss in an ethereal home with a quality of life far superior to anything mere mortals have ever known. Christians proclaim a "hope of Heaven" and "life everlasting" as strong tenets of their faith. Heaven, to the Christian, is not a state of mind or soul. It is a very real place. As Emily Dickinson has stated in her well-known poem:

> *I never saw a moor,*
> *I never saw the sea;*
> *Yet know I how the heather looks,*
> *And what a wave must be.*
> *I never spoke with God,*
> *Nor visited in Heaven;*
> *Yet certain am I of the spot*
> *As if the chart were given.*

In virtually every Christian writing about Heaven, it is described as a place of exquisite beauty and unending joy, where the presence of beloved friends and relatives and an awesome intimacy with a Heavenly Father exists. It is a place ruled by God's will. W. R. Inge says Heaven is a "community filled with holiness, righteousness, and peace."

Why be concerned about Heaven?

It is the Bible first and foremost that promises the hope of Heaven to man. In many ways, the hope of this eternal dwelling purifies our life on earth giving us a new set of priorities about our earthly home and life. C. S. Lewis writes:

> *If you read history you will find that the Christians who did most for the present world were just those who thought more of the next. The apostles themselves, who set on foot the conversion of the Roman Empire, the great men who built up the Middle Ages, the English evangelicals who abolished the Slave Trade, all left their mark on earth, precisely because their minds were occupied with Heaven. It is since Christians have largely ceased to think of the other world that they have become so ineffective in this. Aim at Heaven and you will get earth "thrown in"; aim at earth and you will get neither.*

A Little Bit of Heaven is a collection of essays, sermons, plays, stories, Scripture, songs, poems, and portions of published revelations and visions — all about Heaven. None of these writings are linked to a near-death or death experience. Rather, they are linked to the spiritual experiences, revelation, and divinely creative inspiration of the writers for the purpose of lifting one's eyes from the mundane to the sublime.

It is our hope as you read *A Little Bit of Heaven* that your spirit will soar and that your Christian faith will be affirmed. May you catch a glimpse of a truly glorious realm just beyond our final breath — "knowing that you have a better and an enduring possession for yourselves in Heaven" (Hebrews 10:34 — NKJV).

A MYSTERY - YET REAL

What is Heaven going to be like? Just as there is a mystery to hell, so there is a mystery to Heaven. Yet I believe the Bible teaches that Heaven is a literal place. Is it one of the stars? I don't know. I can't even speculate. The Bible doesn't inform us. I believe that out there in space where there are one thousand million galaxies, each a hundred thousand light years or more in diameter, God can find some place to put us in Heaven. I'm not worried about where it is. I know it is going to be where Jesus is. Christians don't have to go around discouraged and despondent with their shoulders bent. Think of it — the joy, the peace, the sense of forgiveness that He gives you, and then Heaven, too.

BILLY GRAHAM

From Illustration Unlimited edited by James Hewett, ©1988
Used by permission of Tyndale House Publisher, Inc. All Rights Reserved.

HEAVEN TO ME'S
A FAIR BLUE
STRETCH OF SKY,
EARTH'S JUST A
DUSTY ROAD.

**JOHN
MOSEFIELD**

ON THE VERGE

We are in 1903 and I am nearly seventy-one years old. I always thought I should love to grow old, and I find it is even more delightful than I thought. It is so delicious to be done with things, and to feel no need any longer to concern myself much about earthly affairs. I seem on the verge of a most delightful journey to a place of unknown joys and pleasures, and things here seem of so little importance compared to things there, that they have lost most of their interest for me.

I cannot describe the sort of done-with-the-world feeling I have. It is not that I feel as if I am going to die at all, but simply that the world seems to me nothing but a passageway to the real life beyond; and passageways are very unimportant places. It is of very little account what sort of things they contain, or how they are furnished. One just hurries through them to get to the place beyond.

My wants seem to be gradually narrowing down, my personal wants, I mean, and I often think I could be quite content in the poorhouse! I do not know whether this is piety or old age, or a little of each mixed together, but honestly the world and our life in it does seem of too little account to be worth making the least fuss over, when one has such a magnificent prospect close at hand ahead of one; and I am tremendously content to let one activity after another go, and to await quietly and happily the opening of the door at the end of the

passageway, that will let me in to my real abiding place. So you may think of me as happy and contented, surrounded with unnumbered blessings, and delighted to be seventy-one years old.

MRS. PEARSALL SMITH

GOD IS THE APEX

Every bit of love and beauty and truth that anyone ever experiences on earth is made in Heaven and is a participation in Heaven. For Heaven is God's presence; and God is present in all goodness, all truth, and all beauty. God is not a truth, a good, or a beauty, but Goodness Itself and Truth Itself and Beauty Itself. He is neither a particular thing nor an abstract, universal quality, like "goodness in general." He is a concrete universal. In God all goodness, truth, and beauty exist, coexist, meet, and are perfected, like the generatrices of a cone meeting at its point. God is the point of it all. "It all" is Heaven; earth is only Heaven's outer border, the arc of the cone.

PETER J. KREEFT
Heaven: The Heart's Deepest Longing

Peter Kreeft, Heaven: Everything You Ever Wanted to Know Heaven
Ignatius Press, San Francisco, CA.

Bring us, O Lord God, at our last awakening into the house and gate of Heaven, to enter into that gate and dwell in that house, where there shall be no darkness nor dazzling, but one equal light; no noise nor silence, but one equal music; no fears nor hopes, but one equal possession; no ends nor beginnings, but one equal eternity; in the habitations of thy glory and dominion work without end.

JOHN DONNE

JOY: HEAVEN'S "SERIOUS BUSINESS"

I do not think that the life of Heaven bears any analogy to play or dance in respect of frivolity. I do think that while we are in this "valley of tears," cursed with labor, hemmed round with necessities, tripped up with frustrations, doomed to perpetual plannings, puzzlings, and anxieties, certain qualities that must belong to the celestial condition have no chance to get through, can project no image of themselves, except in activities which, for us here and now, are frivolous. For surely we must suppose the life of the blessed to be an end in itself, indeed The End: to be utterly spontaneous; to be the complete reconciliation of boundless freedom with order—with the most delicately adjusted, supple, intricate, and beautiful order. How can you find any image of this in the "serious" activities either of our natural or of our (present) spiritual life? . . . No . . . It is only in our "hours off," only in our hours of permitted festivity, that we find an analogy. Dance and game are frivolous, unimportant down here; for "down here" is not their natural place. Here, they are a moments rest from the life we were placed here to live. But in this world everything is upside down. That which, if it could be prolonged here, would be a truancy, is likest that which in a better country is the End of Ends. Joy is the serious business of Heaven.

C. S. LEWIS
Letters to Malcolm: Chiefly on Prayer

A LAND THAT IS FAIRER THAN DAY

There's a land that is fairer than day,
And by faith we can see it afar;
For the Father waits over the way,
To prepare us a dwelling-place there.

We shall sing on that beautiful shore
The melodious songs of the blest,
And our spirits shall sorrow no more
Not a sigh for the blessing of rest.

To our bountiful Father above,
We will offer our tribute of praise,
For the glorious gift of His love,
And the blessings that hallow our days.

Chorus:
In the sweet by and by,
We shall meet on that beautiful shore;
In the sweet by and by,
We shall meet on that beautiful shore.

J. W. WEBSTER

EVERLASTING JOY

Heaven, which in both Hebrew and Greek is a word meaning "sky," is the Bible term for God's home (Ps. 33:13-14; Matt. 6:9) where his throne is (Ps. 2:4); the place of his presence to which the glorified Christ has returned (Acts 1:11); where the church militant and triumphant now unites for worship (Heb. 12:22-25); and where one day Christ's people will be with their Savior forever (John 17:5,24; 1 Thess. 4:16-27). It is pictured as a country (Heb. 11:16). At some future point, at the time of Christ's return for judgment, it will take the form of a reconstructed cosmos (2 Pe. 3:13; Rev. 21:1).

According to Scripture, the constant joy of Heaven's life for the redeemed will stem from (a) their vision of God in the face of Jesus Christ (Rev. 22:4); (b) their ongoing experience of Christ's love as he ministers to them (Rev. 7:17); (c) their fellowship with loved ones and the whole body of the redeemed; (d) the continued growth, maturing, learning, enrichment of abilities, and enlargement of powers that God has in store for them. The redeemed desire all these things, and without them their happiness could not be complete. But in Heaven there will be no unfulfilled desires.

There will be different degrees of blessedness and reward in Heaven. All will be blessed up to the limit of what they can receive, but capacities will vary just as they do in this world. As for rewards (an area in which present irresponsibility can bring permanent future loss: (1 Cor. 3:10-15), two points must be grasped. The first is that when God rewards our works he is crowning his own gifts, for it was only by grace that those works were done. The second is that essence of the reward in each case will be more of what the Christian desires most,

namely, a deepening of his or her love-relationship with the Savior, which is the reality to which all the biblical imagery of honorific crowns and robes and feasts is pointing. The reward is parallel to the reward of courtship, which is the enriching of the love-relationship itself through marriage.

So the life of heavenly glory is a compound of seeing God in and through Christ and being loved by the Father and the Son, of rest (Rev. 14:13) and work (Rev. 7:15), of praise and worship (Rev. 7:9-10; 19:1-5), and of fellowship with the Lamb and the saints (Rev. 19:6-9). Nor will it end (Rev. 22:5). Its eternity is part of its glory; endlessness, one might say, is the glory of glory.

Hearts on earth say in the course of a joyful experience, "I don't want this ever to end." But it invariably does. The hearts of those in Heaven say, "I want this to go on forever." And it will. There can be no better news than this.

J. I. PACKER

From: Concise Theology, A Guide to Historic Christian Beliefs, by : J. I. Packer Copyright © 1993 Foundation for Reformation
Used by permission of Tyndale House Publishers, Inc. All rights reserved.

UTTERLY
WORTHWHILE

U sing the framework provided by the beatitudes, we can describe quite a bit of what Heaven is like. It is that state of being in which we shall be comforted, made heirs of all of the earth's richest treasure, filled to the brim so that our deepest longings are satisfied. It is that eternal dwelling where we shall receive mercy, pardon, restoration, and rebirth. Then we shall behold God and work and play with him among those who love him. This is Heaven. Boethius once summed it all up in one sentence: Heaven is the simultaneous fruition of life without bounds. It is like a bud bursting into eternal bloom, and a blossom ripening into eternal fruit. And then the process of bud and bloom and fruition starts over, again and again. Heaven is like emerging from a dark tunnel into the full light of day . . .

Heaven is the place where we will find those kindly, fine, noble, courageous, self-effacing, humble, understanding, forgiving, striving spirits whom we have loved on earth. It is the place and state of being where they are happy and at home. Such a place certainly looks very worthwhile to me.

MORTON T. KELSEY

18

THE ANSWER TO HUMAN LONGING

Heaven is God's answer to all natural human longing. There will be no regimentation in Heaven. God, who makes no two snowflakes alike, no two stars alike, will not destroy our personalities. However, he will deliver us from our faults and imperfections, win for us the battles we have lost in time; help us to succeed where we have failed; deliver us from flaws and imperfections. We shall be perfect, even as our Father in Heaven is perfect. God's likeness will be fully restored in man. All inclination of evil will be gone; all desire will be for the high, the holy, the noble and the true. All the good we have ever hoped for will be realized; all truth shall be ours. No man will need to ask of his brother; he will be fully prepared to occupy the place prepared for him and to control justly and care for all God places in his care.

F. OLEN HUNT, SR.

BEYOND THE SENSES

Heaven—then, what is it? First, what is it not? It is not a Heaven of the senses—"eye hath not seen it." What glorious things the eye hath seen! Have we not seen the gaudy pageantry of pomp crowding the gay streets? We have seen the procession of kings and princes; our eyes have been feasted with the display of glittering uniforms, of lavished gold and jewels, of chariots and of horses; and we have perhaps thought that the procession of the saints of God may be dimly shadowed forth thereby. But, oh it was but the thought of our poor infant mind, and far enough from the great reality. We may hear of the magnificence of the old Persian princes, of palaces covered with gold and silver, and floors inlaid with jewels; but we cannot thence gather a thought of Heaven, for "eye hath not seen" it. We have thought, however, when we have come to the works of God, and our eye hath rested on them: surely we can get some glimpse of what Heaven is here. By night we have turned our eye up to the blue azure, and we have seen the stars—those golden-fleeced sheep of God, feeding on the blue meadow of the sky, and we have said, "See! those are the nails in the floor of Heaven up yonder;" and if this earth has such a glorious covering what must that of the kingdom of Heaven be? And when our eye has wandered from star to star, we have thought, "Now I can tell what Heaven is by the beauty of its floor." But

20

it is all a mistake. All that we can see can never help us to understand Heaven. At another time we have seen some glorious landscape; we have seen the white river winding among the verdant fields like a stream of silver, covered on either side with emerald; we have seen the mountain towering to the sky, the mist rising on it, or the golden sunrise covering all the east with glory; or we have seen the west, again, reddened with the light of the sun as it departed; and we have said, "Surely, these grandeurs must be something like Heaven; we have clapped our hands, and exclaimed-

'Sweet fields beyond the swelling flood,
Stand dressed in living green.'"

C.H. SPURGEON

21

ETERNAL BLISS

Heaven is where God dwells and where dwell other beings, whether of human stock or not, who enjoy eternal bliss . . . Heaven is where everything is as it should be. It provides the criterion of all fitness and rightness. Heaven is where the drama of divine creation begins and Heaven is where it ends . . .

The joy of Heaven will be the renewing of all those relationships in the presence of Him Who was the source of everything that made them good and truly glorious.

HARRY BLAMIRES

Think of—
Stepping on shore,
and finding it Heaven!
Of taking hold of a hand,
and finding it God's hand
Of breathing a new air,
and finding it celestial air.
Of feeling invigorated,
and finding it immortality.
Of passing from storm to tempest
to an unbroken calm.
Of waking up, and finding it Home.

———————————————————

UNKNOWN

FIVE MINUTES ...

I t may be a moment, or after months of waiting, but soon I shall stand before my Lord. Then in an instant all things will appear in new perspective.
Suddenly the things I thought important — tomorrow's tasks, the plans for the dinner at my church, my success or failure in pleasing those around me — these will matter not at all. And the things to which I gave but little thought — the word about Christ to the man next door, the moment (how short it was) of earnest prayer for the Lord's work in far-off lands, the confessing and forsaking of that secret sin — will stand as real and enduring.

Five minutes after I'm in Heaven I'll be overwhelmed by the truths I've known but somehow never grasped. I'll realize then that it's what I am in Christ that comes first with God, and that when I am right with Him, I do the things which please Him. I'll sense that it was not just how much I gave that mattered, but how I gave — and how much I withheld.

In Heaven I'll wish with all my heart that I could reclaim a thousandth part of the time I've let slip through my fingers, that I could call back those countless conversations which could have glorified my Lord but didn't.

Five minutes after I'm in Heaven, I believe I'll wish with all my heart that I had risen more faithfully to read the Word of God and wait on Him in prayer — that I might have known Him while still on earth as He wanted me to know Him.

A thousand thoughts will press upon me, and though overwhelmed by the grace which admits me to my heavenly home, I'll wonder at my aimless earthly life. I'll wish . . . if one may wish in Heaven—but it will be too late.

Heaven is real and hell is real, and eternity is but a breath away. Soon we shall be in the presence of the Lord we claim to serve. Why should we live as though salvation were a dream—as though we did not know?

"To him that knoweth to do good, and doeth it not, to him it is sin."

There may yet be a little time. A new year dawns before us. God help us to live now in the light of a real tomorrow!

MOODY MONTHLY
January 1952

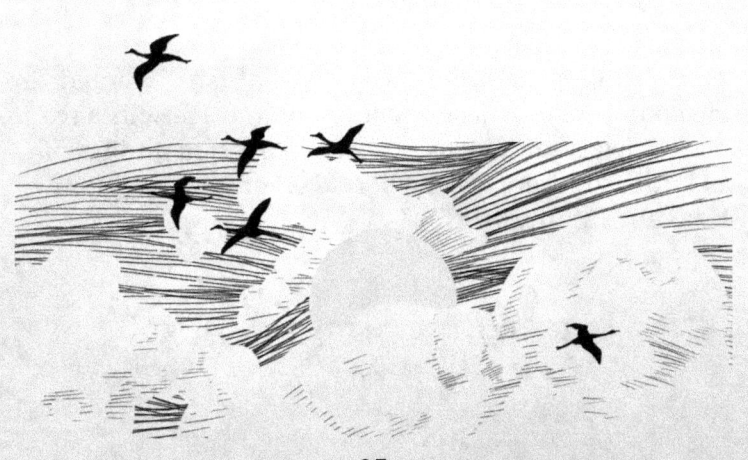

NO LONGER BOUND

Spend in pure converse our eternal day; think each in each, immediately wise; learn all we lacked before; hear, know, and say what this tumultuous body now denies; and feel, who have laid our groping hands away; and see, no longer blinded by our eyes.

RUPERT BROOKE

A little girl, when asked what she wanted in Heaven, replied: "Jesus will know and He will have it there." Jesus said, "Except ye be converted and become as little children, ye shall not enter the kingdom of Heaven" (Matthew 18:3, KJV).

F. OLEN HUNT, SR.

One sweetly solemn thought
comes to me o'er and o'er;
I'm nearer to my home to-day
than I've ever been before;
Nearer my father's house,
where the many mansions be;
Nearer the great white throne,
nearer the jasper sea;
Nearer the bound of life,
where I lay my burden down;
Nearer leaving my cross;
nearer wearing my crown!

PHOEBE CARY

HEAVEN TO THE CHRISTIAN

A portion of an interview between Dr. Page Patterson and Dr. W.A. Criswell:

Patterson: How is the Christian concept of Heaven different from concepts of the afterlife in other religions?

Criswell: Though we are not going to criticize other faiths, let us focus, for example, upon the Mohammedan's idea of Heaven. He sees Heaven as a big harem in which he is going to live and indulge his carnal lust with forty women.

The Buddhist's idea of Heaven is Nirvana—nothingness. He looks forward to being unmoved and unaware of anything other than mere existence.

The Hindu has an extended vacation between reincarnations, believing that one continues after death to come back again and again.

All of these concepts are different from the Christian faith. A Christian's concept of Heaven is that we are going to be with Jesus and with one another; we are going to be perfect; we are going to praise God for His goodness to us world without end.

Our concept of Heaven does not have the self-centeredness of other afterlife concepts. We put all of our energies and thoughts toward serving God the Father instead of being concerned about what happens to us.

Patterson: What are some metaphors or euphemisms used in Scripture for Heaven that you think are important?

Criswell: Everything that is affirmative for the richness of human life would be a beautiful vocabulary to use to describe Heaven—the joy of the soul, the happiness of the heart, the cognizance of the mind, the understanding of our hearts, the infinite praise with which we will worship our Lord, the glories of being in a society without hurt or harm or sin or pain or death or suffering. Every good word that is known to the human experience can be used to describe what God has in store for those who love Him in Heaven.

W.A. CRISWELL AND
PAIGE PATTERSON
Heaven

By: W. A. Criswell & Paige Patterson copyright © 1991
Used by permission of Tyndale House Publisher, Inc. All rights reserved.

TRUE PIE IN THE SKY

Scripture and tradition habitually put the joys of Heaven into the scale against the sufferings of earth, and no solution of the problem of pain which does not do so can be called a Christian one. We are very shy nowadays of even mentioning Heaven. We are afraid of the jeer about "pie in the sky," and of being told that we are trying to "escape" from the duty of making a happy world here and now into dreams of a happy world elsewhere. But either there is "pie in the sky" or there is not. If there is not, then Christianity is false, for this doctrine is woven into its whole fabric. If there is, then this truth, like any other, must be faced, whether it is useful at political meetings or no. Again, we are afraid that Heaven is a bribe, and that if we make it our goal we shall no longer be disinterested. It is not so. Heaven offers nothing that a mercenary soul can desire. It is safe to tell the pure in heart that they shall see God, for only the pure in heart want to. There are rewards that do not sully motives. A man's love for a woman is not mercenary because he wants to marry her, nor his love for poetry mercenary because he wants to read it, nor his love of exercise less disinterested because he wants to run and leap and walk. Love, by definition, seeks to enjoy its object.

C.S. LEWIS
Problem of Pain

HEAVENLY PROPERTY

FREE BEAUTIFUL HOMES
to be
GIVEN AWAY in a PERFECT CITY!

with:

100% Pure Water Free
No Light Bills
Perpetual Lighting
Permanent Pavement
Nothing Undesirable
Everything New
Perfect Health
Immunity from Accidents
The Best of Society
Beautiful Music
Free Transportation

SECURE A CONTRACT TODAY FOR THE NEW
JERUSALEM

THE BIBLE FRIEND

SPEAKING OF HEAVEN

Charles E. Fuller once announced that he would be speaking the following Sunday on "Heaven." During that week a beautiful letter was received from an old man who was very ill. The following is part of his letter:

"Next Sunday you are to talk about Heaven. I am interested in that land because I have held a clear title to a bit of property there for over fifty- five years. I did not buy it. It was given to me without money and without price. But the Donor purchased it for me at tremendous sacrifice. I am not holding it for speculation since the title is not transferable. It is not a vacant lot.

"For more than half a century I have been sending materials out of which the greatest Architect and Builder of the Universe has been building a home for me which will never need to be remodeled nor repaired because it will suit me perfectly, individually, and will never grow old.

"Termites can never undermine its foundations for they rest on the Rock of Ages. Fire cannot destroy it. Floods cannot wash it away. No locks nor bolts will ever be placed upon its doors, for no vicious person can ever enter that land where my dwelling stands, now almost completed and almost ready for me to enter in and abide in peace eternally, without fear of being ejected.

"There is a valley of deep shadow between the place where I live in California and that to which I shall

journey in a very short time. I cannot reach my home in that City of Gold without passing through this dark valley of shadows. But I am not afraid because the best Friend I ever had went through the same valley long, long ago and drove away all its gloom. He has stuck by me through thick and thin, since we first became acquainted fifty-five years ago, and I hold His promise in printed form, never to forsake me or leave me alone. He will be with me as I walk through the valley of shadows, and I shall not lose my way when He is with me

"I hope to hear your sermon on Heaven next Sunday from my home in Los Angeles, California, but I have no assurance that I shall be able to do so. My ticket to Heaven has no date marked for the journey—no return coupon—and no permit for baggage. Yes, I am all ready to go and I may not be here while you are talking next Sunday evening, but I shall meet you there some day."

MESSENGER OF PEACE

33

PREPARED PLACE

I go to prepare a place for you . . .

JOHN 14:2

The Lord Jesus could have used any word, any symbol to tell us where we would spend eternity. But He always chose words very carefully, and so in this instance He used the word "place."

I live in a place, high on a mountain in a log cabin in North Carolina. This place has an address. If you send a letter to me, the postman knows where to deliver it.

In saying that He was going to prepare a place for us, Jesus was telling us that when we die, we are going to a precise location. We do not evaporate or disappear. In fact, He said, "In my Father's house are many mansions." We are going to have a place in Heaven if we have trusted Christ as our Savior — and not only a place, but a mansion!

When we as Christians die, we go straight into the presence of Christ, straight to that place, straight to that mansion in Heaven to spend eternity with God. We are simply changing our address, much as we would if we moved to another place on earth. If the post office was capable of delivering the mail in Heaven, we could fill out a change of address

form because the place we are going to has an address just as the place in which we are now living has an address. It is a real place.

BILLY GRAHAM
Unto the Hills

TREASURE WITHOUT DECAY

Jesus taught:

"Do not lay up for yourselves treasures on earth, where moth and rust destroy and where thieves break in and steal; but lay up for yourselves treasures in Heaven, where neither moth nor rust destroys and where thieves do not break in and steal. For where your treasure is, there your heart will be also."

MATTHEW 6:19-21 NKJV

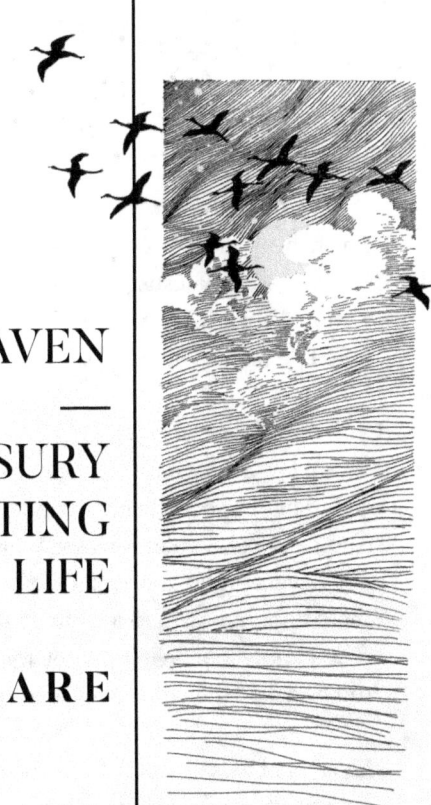

HEAVEN

—

THE TREASURY
OF EVERLASTING
LIFE

SHAKESPEARE

WHEN I GET TO HEAVEN

I have heard a lot of singing 'bout the land beyond the blue,
And the place that Jesus promised that He'd fix for me and you.
And I've heard the people talk about the land that is to be;
So I've made a little list of things I, specially want to see.

Oh, I want to see St. Peter when I've reach'd that land on high;
Want to ask him for the address of my mansion in the sky.
Then I'll stand upon the curbstone, long the shining street of gold,
And I'll look my mansion over where I'll live while ages roll.
Now I have a precious daddy who has fought and won the fight;
Want to hunt him up and tell him that I made it through all right.
Oh, I know that he'll be happy for he often prayed for me,
And he asked the Lord to make me just the man I ought to be.

Then I want to stay around a lot the place where angels sing —
Just what that angel choir is like I have long been wondering.
But when I have caught the rhythm of the anthem of the skies —
Then I want to help the angels sing the songs of paradise.
I'm intending to be present when the marriage feast is spread,
Oh, I want to watch the Savior as He breaks and serves the bread.
And I want to see the light that shines upon His blessed face —
As He lifts again His nail-scarr'd hands and leads in saying grace.

When the angel takes the book of life in which our names are set;
And he starts to read them over going down the alphabet.

And he fin'ly comes to my name, reads it out so loud and clear—
Then I'll stand up on my tiptoes, raise my hand and answer "Here!"
When I get up to Heaven, when I've run and won the race,
And I fin'ly stand in gloryland a sinner saved by grace.
And I hear the hallelujahs and the glad hosannas ring—
As the saints from ev'ry tribe and tongue their Saviour's praises
sing.

JAMES OTIS HARRELL

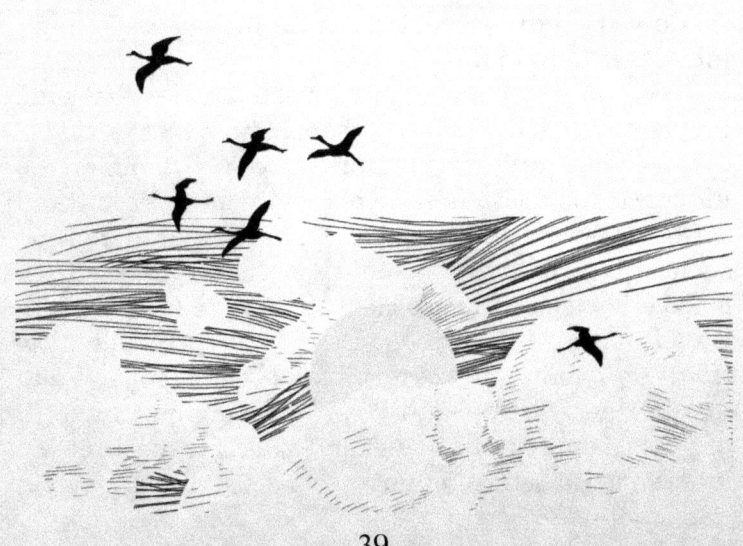

BETTER COUNTRY

You consider yourselves to be exiles, strangers and pilgrims on earth. Knowing that you have no continuing city, no permanent residence in this world, you are marching with courage and ardor to the heavenly Canaan. A foretaste of the fruit of that better country inflames your desires and quickens your progress. You are fully satisfied, that the heavenly is infinitely better than any earthly country, because, in the first place, it is perfectly exempt from sin, whose poisonous breath has infected this globe with all its contents and appendages — whose prolific seed has given birth to innumerable evils of every name, size, complexion and form — whose dismal, pretentious shadow has enveloped the whole human race, in an intellectual and moral eclipse.

How indescribably happy must that place, that soul, that family, that community, that country, that world be, in which sin, guilt, and remorse have no dominion, no influence, no existence. Experience, fact, reason and Scripture afford incontestable evidence, that there is no such a place, nor such a country in this world. But such a place, such a country is Heaven. Who would not with David, wish for the wings of a dove, that he might fly from the tempests of this cloudy atmosphere and insalubrious climate, and be at rest! Omnipotent spirit of grace, sanctify our souls, and make us meet for the inheritance of saints in light!

40

But again, the heavenly is infinitely better than any earthly country, because, it is completely free from death, pain and sorrow.

In the heavenly country, every tear shall be wiped from our eyes. "There the wicked cease from troubling and the weary are at rest. At God's right hand, are fullness of joys and pleasure for evermore." There Eden blooms with more than primeval beauties. Neither the freezing winds of adversity nor all the storms of death and hell can enter there, to wither the flowers of the celestial Paradise. Eternity will brighten every tint and augment every perfume.

Lastly, the society of the heavenly country is infinitely better than any society on earth. The holiest, wisest, best characters in this world, are subject to imperfections, defects and sin; but glorified saints and angels of light, are consummately holy, wise and happy. The capacious powers of their immortal, beautified souls, are expanded and sublimed with all the inexhaustible treasures of divine knowledge, love and truth. All the secrets of nature, the labyrinths of Providence, and the mysteries of Redemption, are unveiled to their astonished, transported minds. From every atom of creation, every event of Providence and article of Redemption, a blaze of perfect order, wisdom,

justice, goodness and glory bursts upon their sight.

Ye highly favored possessors of Faith and heirs of Heaven! You shall enjoy with angelic spirits and the souls of just men made perfect, the most edifying, enrapturing converse; the most pure, ecstatic friendship and love, union and communion. There you shall meet and dwell with all your pious, deceased parents and children, brethren and sisters, relations and friends, in bliss, that eye hath not seen, ear hath not heard, nor heart conceived. Let us all, my friends through Heaven's aid, on the wings of faith, love and holiness, soar to sublime and more exalted heights of devotion and happiness. Whilst our feet and bodies are on earth, let our hearts, our affections and conversation be in Heaven. Let us cheerfully, resolutely, and faithfully follow Jesus, the gracious author of our Faith, and captain of our salvation, through this wilderness, and he will, at the end of our journey, bless us with the full fruition of all the indescribable treasures of that better, heavenly country, in which there is an eternity of perfect bliss, and a never-ending association of holy angels and glorified saints. Into that happy, celestial assembly, may the Lord, finally, bring us all! And to the adorable Trinity, shall be ascribed all possible praise, honor and glory, now and forever. Amen.

JOHN M. ROBERTS

"A Better Country," sermon delivered before the Charleston Baptist Association, 1809

"I cannot think what we shall find to do in Heaven," mused Luther. "No change, no work, no eating, no drinking, nothing to do."

"Yes, " says Melanchthon, "Lord, show us the father, and it sufficeth us.'"

"Why, of course," responded Luther, "that sight will give us quite enough to do!"

MARTIN LUTHER

HEAVEN IS:

It is held forth to our view as a banquet, where our souls shall be satisfied forevermore; the beauties of Jehovah's face, the mysteries of divine grace, the riches of redeeming love, communion with God and the Lamb, fellowship with the infinite Father, Son, and Holy Ghost, being the heavenly fullness on which we shall feed.

As a *paradise* — a garden of fruits and flowers, on which our spiritual natures and gracious tastes will be regaled through one ever-verdant spring and golden summer; a paradise where lurks no serpent to destroy, and where fruits and flowers shall never fade and droop, nor die.

As an *inheritance*: but then an inheritance that is incorruptible, undefiled, and that fadeth not away — the inheritance of the saints in light.

As a *kingdom*, whose immunities, felicities, and glories are splendid and vast, permanent and real, quite overwhelming, indeed, to our present feeble imaginings.

As a *country* over whose wide regions we shall traverse in all the might of our untried faculties, and in all the glow of new and Heaven-born energies, discovering and gathering fresh harvests of intelligence, satisfaction, and delight.

As a *city* whose walls are burnished gold, whose pavement is jasper, sardonyx, and onyx, through which flows the river of life; the inhabitants of which hunger no more, thirst no more, sicken no more, weep no more, die no more; a city where there is no need of the sun by day, in

which there is no night at all, and of which the Lord God Almighty is the light, and the Lamb, the glory.

As a *palace*, where dwells the Lord our righteousness, the King in His beauty displayed—His beauty of holiest love; in the eternal sunshine of whose countenance bask and exult the host who worship at His feet.

As a *building* that has God for its Maker, immortality for its walls, and eternity for its day.

As a *sanctuary*, where the thrice-holy divinity enshrined in our own nature in the person of Immanuel is worshiped and adored, without a sigh, without an imperfection, and without intermission; where hymns of praise, hallelujahs of salvation, and hosannas of redemption, uttered by blest voices without number, ever sound before the throne.

As a *temple* bright with the divine glory, filled with the divine presence, streaming with divine beauty, and peopled with shining monuments of divine goodness, mercy, and grace.

DR. BEAUMONT
Metaphors

WHERE RAINBOWS NEVER FADE

It cannot be that the earth is man's only abiding place. It cannot be that our life is a mere bubble cast up by eternity to float a moment on its waves and then sink into nothingness. Else why is it that glorious aspirations which leap like angels from the temple of our hearts are forever wandering unsatisfied? Why is it that all the stars that hold festival around the midnight throne are set above the grasp of our limited faculties, forever mocking us with their unapproachable glory? And, finally, why is it that bright forms of human beauty presented to our view are taken from us, leaving the thousand streams of our affections to flow back in Alpine torrents upon our hearts? There is a realm where the rainbow never fades; where the stars will be spread out before us like islands that slumber in the ocean, and where the beautiful beings that now pass before us like shadows will stay in our presence forever.

GEORGE E. PRENTICE

I have always considered [Heaven] in terms of relationships. We will be in relationship with our Lord, free of all our human limitations. We will know him as he is and will be known as we will be in complete reconciliation, harmony, and limitless love. We will know and love each other free from human fear, competition, and anxiety. We will be completely one with our Lord and with each other.

LLOYD JOHN OGILVIE

A WOMAN'S DREAM

Look where I would, I saw, half hidden by the trees, elegant and beautiful houses of strangely attractive architecture, that I felt must be the homes of the happy inhabitants of this enchanted place. I caught glimpses of sparkling fountains in many directions, and close to my retreat flowed a river, with placid breast and water clear as crystal. The walks that ran in many directions through the grounds appeared to me to be, and I afterward found were, of pearl, spotless and pure, bordered on either side by narrow streams of pellucid water, running over stones of gold. The one thought that fastened itself upon me as I looked, breathless and speechless, upon this scene, was "Purity, purity!" No shadow of dust; no taint of decay on fruit or flower; everything perfect, everything pure. The grass and flowers looked as though fresh-washed by summer showers, and not a single blade was any color but the brightest green. The air was soft and balmy, though invigorating; and instead of sunlight there was a golden and rosy glory everywhere; something like the afterglow of a Southern sunset in midsummer.

REBECCA RUTER SPRINGER
Intra Muros —"My Dream of Heaven"[1]

UNHINDERED SIGH

We will contemplate God, directly, without the intermediacy of creatures or the shadows of faith. We shall no longer reason over God's being from His works, we shall see His very self. No longer effects, but His essence, will determine our knowledge. Obviously, there is question here of a spiritual activity, but the word "see" is the best, since sight affords the clearest and fullest knowledge. Sight engenders insight. But God does not exhibit Himself as a thing; God shows Himself as a person. We find this in the Bible, when there is question of seeing the face of God. The face shows us not only a person's natural self, but also his intimate personality which he reveals in looking at us.

We shall not look at God, we shall regard Him, and He will regard us. We will not only see His countenance, but there will be "face to face" contact. It is good to remember that the expression "face to face" has its origin in the description of a conversation. It is in conversation that revelation of ourselves is a gift of the highest degree, for words are the clearest revelation of self, especially in an intimate conversation. Nevertheless, words are not enough to reveal the integral reality; no one can express himself fully in words. That is why "face to face" is the best image of our external contact with God. This contact can be compared to a deeper intuitive contact; the image of the heavenly Jerusalem compared to a bride is suggestive in this sense, but in the end, all images are powerless to express the intimacy and plenitude of the gift God will make of Himself.

PETER SCHOONENBERG, S. J. [2]

CATCHING UP WITH OUR HEART

Some people find it difficult to think realistically about Heaven.

It's little wonder we feel so blasé about it all. The image most people concoct about Heaven is anything but appealing. Some imagine it a spooky kind of twilight zone. Others visualize it tucked behind a galaxy where birds chirp and organs play with heavy tremolo and angels bounce from cloud to cloud.

If that were a true picture of Heaven, I'd be lukewarm about going there, too.

But the fact is that we believers are headed for Heaven. It's reality. Heaven may be as near as next year — or next week. So it makes good sense to spend some time here on earth thinking candid thoughts about that future reserved for us.

I admit, it's tough to muster excitement about a place we've never seen. So how do we go about bringing Heaven into focus?

Someone once said that Christ brings the heart to Heaven first — and then He brings the person. I like that. God knows you and I would have a tough time fixing our eyes on Heaven unless our heart was really involved. That's why our Lord's words in Matthew 6:21 ring so true: "For where your treasure is, there will your heart be also" (KJV).

In other words, if our investments are in Heaven, God knows our heart's desire will be there, too.

I'm convinced this little verse in Matthew 6 holds the secret. The only way we can enjoy the thought of Heaven, the only way we can start thinking of it as reality, is to allow God to take our heart home first. Once we start investing in eternity, Heaven will begin to come into focus. As we give sacrificially

of our energies or money, as we spend more time in prayer, praising God rather than petitioning Him, as we witness boldly and fearlessly . . . we're making deposits in eternity. We're putting more and more of ourselves on the other side. As we continue to do these things, we'll wake up one morning to find our heart precisely where it should be . . . in Heaven.

Our future Home won't seem like an eerie twilight zone. It won't fill our thoughts with saccharin visions of bluebirds, chubby angels, and rainbows. No, it will take shape in our minds as the Real Estate of Heaven it actually is, the place where God dwells, and prepares for our coming.

"Your eyes will see the king in his beauty and view a land that stretches afar" (Isaiah 33:17 NIV). All the other trappings — golden streets, pearly gates, and crystal rivers — aren't nearly as important.

What is important is that we will see our King and live with Him forever. In that shining moment we will finally catch up with our hearts — and our heart's desire. God Himself.

And that will be enough.

JONI EARECKSON TADA

51

UPWARD!

Many saints are content to live like men in coal mines, who see not the sun. Tears mar their faces when they might anoint them with celestial oil. Satisfied I am that many a believer pines in a dungeon when he might walk on the palace roof, and view the goodly land and Lebanon. Rouse thee, O believer, from thy low condition! Cast away thy sloth, thy lethargy, thy coldness, or whatever interferes with thy chaste and pure love to Christ. Make Him the source, the center, and the circumference of all thy soul's range of delight. Rest no longer satisfied with thy dwarfish attainments. Aspire to a higher, a nobler, a fuller life. Upward to Heaven! Nearer to God!

C. H. SPURGEON

Here [on earth] one may be lower than another in honor, and yet the highest want glory: there, though one star differs from another in glory, they all shine as stars. Here the greatest must want—there the least hath enough. Here all the earth may not be enough for one—there one Heaven is enough for all.

———————————————————————

ARTHUR WARWICK

AS BEAUTIFUL AS A BRIDE

Heaven will be as expansive as the universe itself. It will be as wonderful and beautiful as only the Creator God can make it. Everything for your personal happiness and enjoyment is being prepared. Every longing and every desire will have perfect fulfillment. One of the descriptions of Heaven is that found on the Bible's concluding pages where it says: "And I John saw the holy city, new Jerusalem, coming down from God out of Heaven, prepared as a bride adorned for her husband" (Revelation 21:2 KJV). There is nothing more universally beautiful than a bride. Think of all the anticipation, care, and preparation of a bride. Her dress, her hair, her bearing, her smile, and her transparent joy all combine to make her wedding moment the most transcendent event of her life. I have never seen an unlovely bride, and the Bible uses this beauty to describe Heaven.

BILLY GRAHAM

54

GUEST OF GOD

From the dust of the weary highway,
From the smart of sorrow's rod,
Into the royal Presence,
They are bidden as guests of God.
The veil from their eyes is taken,
Sweet mysteries they are shown,
Their doubts and fears are over,
For they know as they are known.
For them there should be rejoicing
For them the festal array,
As for the bride in her beauty,
Whom love hath taken away;
Sweet hours of peaceful waiting,
Till the path that we have trod,
Shall end at the Father's gateway,
And we are the guests of God.

MRS. CHARLES COWAN

PERFECTION

Heaven will be the perfection we have always longed for. All the things that made earth unlovely and tragic will be absent in Heaven. There will be no night, no death, no disease, no sorrow, no tears, no ignorance, no disappointment, no war. It will be filled with health, vigor, virility, knowledge, happiness, worship, love, and perfection.

Heaven will be more modern and up to date than any of the present-day constructions of man. Heaven will be a place to challenge the creative genius of the unfettered mind of redeemed man. Heaven will be a place made supremely attractive by the presence of Christ.

One of the almost unmentioned wonders of Heaven will be the varied kinds of beings represented in its population. Some are called princes, others potentates, others rulers, for there will be thrones, principalities, and powers to be occupied by various ranks of celestial princes. There will be seraphim and cherubim, angel and archangel, Gabriel and Michael, plus the innumerable myriads who tread the celestial courts and palaces. These will surround God on His throne to recognize His Majesty, ever attentive to His orders, watching over the inhabitants of the celestial worlds.

When we have compressed the Bible's descriptions of Heaven into a composite picture, we find it to be a

56

new Heaven and a new earth crowned by "a city whose builder and maker is God." In the book of Revelation, John pictures it as having trees, flowing fountains, fruits, robes, palms, music, crowns, precious stones, gold, light, colors of the rainbow, water, knowledge, friendship, love, holiness, and the presence of God and His Son. This and much more will be Heaven!

BILLY GRAHAM

LOVE'S FULFILLMENT

My God, I pray that I may so know you and love you that I may rejoice in you, and if I may not do so fully in this life, let me go steadily on to the day when I come to that fullness. Let your love grow in me here and there let it be fulfilled so that there my joy may be in a great hope and there in full reality.

PROSLOGION

Every saint in Heaven is as a flower in the garden of God, and holy love is the fragrance and sweet odor that they all send forth, and with which they fill the bowers of that paradise above. Every soul there is as a note in some concert of delightful music, who sweetly harmonizes with every other note, and all together blend in the most rapturous strains in praising God and the Lamb forever.

JONATHAN EDWARDS

PERFECT PURITY,
FULLNESS OF JOY,
EVERLASTING
FREEDOM,
PERFECT REST,
HEALTH, AND
FRUITION,
COMPLETE
SECURITY,
SUBSTANTIAL
AND ETERNAL
GOOD.

**HANNAH
MOORE**

JESUS: FACE TO FACE

However, the most thrilling thing to me about Heaven is that Jesus Christ will be there. I will see Him face to face. I will have the opportunity to talk directly to Him and to ask Him a hundred questions that I have never had answered.

Sometimes we get a little tired of the burdens of life, but it is exhilarating to know that Jesus Christ will meet us at the end of life's journey. The joy of being with Him forever is beyond the ability of any writer to describe.

BILLY GRAHAM
Facing Death and the Life After

PERFECT COMMUNION

Love for our neighbor is assimilated to the love for God even on earth, but even more so at the end of time. Even now the knowledge of God cannot be disassociated from the knowledge of creatures. The communion with God will be the most intimate possible for each one; it will have a name which none but the bearer knows. At the same time, there will be perfect communion among the elect, just because God will be all in all. It will be the perfect community of the Trinity, assuming all the elect within itself. "Behold the tabernacle of God with men; and He will dwell with them. And they shall be His people, and God Himself with them shall be their God."

PETER SCHOONENBERG, S. J. 4

HEAVEN ARISTOCRACY

The society of Heaven will be select. No one who studies Scripture can doubt that. There are a good many kinds of aristocracy in this world, but the aristocracy of Heaven will be the aristocracy of holiness. The humblest believer on earth will be an aristocrat there. It says in the 57th chapter of Isaiah: "For thus saith the High and Lofty One, that inhabiteth eternity, whose name is Holy; I dwell in the high and holy place, with him also that is of a contrite and humble spirit." (v:15). Now what could be plainer than that? No one who is not of a contrite and humble spirit will dwell with God in His high and holy place.

DWIGHT L. MOODY

THERE IS A LAND
OF PURE
DELIGHT, WHERE
SAINTS
IMMORTAL
REIGN; INFINITE
DAY EXCLUDES
THE NIGHT, AND
PLEASURES
BANISH PAIN.

ISAAC WATTS

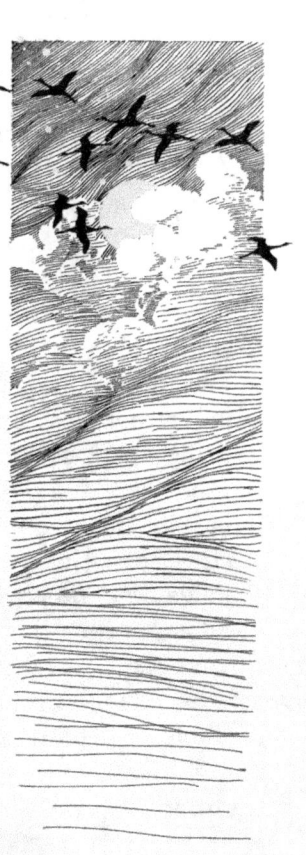

THE SUMMIT OF DESIRE

This kingship promised to the blessed in the Scriptures involves first of all a manifest triumph and undoubted victory over all adverse powers, over the devils and the damned that tempted them and endeavored to hinder them in the attainment of their final end, over the obstacles that stood in their way through the frailty of their own nature and the greatness of their task. The blessed will be like Alpine travelers, who have at least reached the dazzling heights. They have attained the very summit of their desires notwithstanding the storms that raged, the foes that waylaid them, and the steepness of the path they climbed. It includes, further, an untrammeled freedom during eternity, a full liberty and immediate fulfillment of their wishes, and a complete disposal of all the riches of their royal inheritance without any possibility of being thwarted or gainsaid. It includes, lastly, a real dominion over all creation. At the final consummation, after the resurrection of the body, they will have a complete mastery over all material things, and all nature will obey them, and submit to their sovereignty. Even in the spiritual world of angels and fellow-saints they will reign, for they will be as princes amongst princes, all of whom in celestial courtesy will pay honor one to another. With utter spontaneity and eagerness all will serve God, to serve whom is to reign . . .

In Heaven the blessed will see all things in God and God in all things. They will see all things in that divine order in which they stand in God's mind. Their place and position in the universe that God created will be understood, for the outlook of the saints on all things will resemble that of God.

J. P. ARENDZEN

JOY UNSPEAKABLE

I believe that they who have their part in this Resurrection, shall meet the Lord in the air, and when the blessed sentence is pronounced upon them, they shall forever be with the Lord in joys unspeakable and full of glory: God shall wipe all tears from their eyes; there shall be no fear or sorrow, no mourning or death, a friend shall never go away from thence, and an enemy shall never enter; there shall be fullness without want, light eternal brighter than the sun; day, and no night; joy, and no weeping; difference in degree, and yet all full; there is love without dissimulation, excellence without envy, multitudes without confusion, music without discord; there the understandings are rich, the will is satisfied, the affections are all love, and all joy, and they shall reign with God and Christ forever and ever.

JEREMY TAYLOR

MADE TO FIT

Your soul has a curious shape because it is a hollow made to fit a particular swelling in the infinite contours of the divine substance, or a key to unlock one of the doors in the house with many mansions. For it is not humanity in the abstract that is to be saved, but you — you, the individual reader Blessed and fortunate creature, your eyes shall behold Him and not another's. All that you are, sins apart, is destined if you will let God have His good way, to utter satisfaction Your place in Heaven will seem to be made for you and you alone, because you were made for it.

C. S. LEWIS
The Problem of Pain

UNTOLD DIVERSITY

Among the good whom we hope to meet in Heaven, we are told there will be every variety of character, taste, and disposition. There is not one there; there are many. There is not one gate to Heaven, but many. There are not only three gates on the north, but on the east three gates, and on the west three gates, and on the south three gates. From opposite quarters of the theological compass, from opposite quarters of the religious world, from opposite quarters of human life and character, through different expressions of their common faith and hope, through different modes of conversion, through different portions of the Holy Scripture, will the weary travelers enter the Heavenly City, and meet each other—"not without surprise" —on the shores of the river of life. And on those shores they will find a tree bearing, not the same kind of fruit always and at all times, but "twelve manner of fruits," for every different turn of mind—for the patient sufferer, for the active servant, for the holy and humble philosopher, for the spirits of just men now at last made perfect: and "the leaves of the tree shall be for the healing." Not of one single church or people only, not for the Scotchman or the Englishman only, but for "the healing of the nations"—the Frenchman, the German, the Italian, the Russian—for all those from whom, it may be, in this, its fruits have been farthest removed, but who, nevertheless, have "hungered and thirsted after righteousness," and therefore "shall be filled."

DWIGHT L. MOODY

HOW BIG IS HEAVEN?

The very nature of space, and therefore of size, changes in Heaven. Meaning determines size, rather than size, meaning. The New Jerusalem's measures are symbolic, not physical. Heaven is big enough so that billions of races of billions of saved people are never crowded, yet small enough so that no one gets lost or feels lonely. And we can travel anywhere in Heaven simply by will.

PETER J. KREEFT
Everything You Ever Wanted to Know About Heaven

LOCATING HEAVEN

Surely it is not wrong for us to think and talk about Heaven. I like to locate it, and find out all I can about it. I expect to live there through all eternity. If I were going to dwell in any place in this country, if I were going to make it my home, I would inquire about its climate, about the neighbors I would have, about everything, in fact, that I could learn concerning it. If soon you were going to emigrate, that is the way you would feel. Well, we are all going to emigrate in a very little while. We are going to spend eternity in another world, a grand and glorious world where God reigns. Is it not natural that we should look and listen and try to find out who is already there, and what is the route to take?

DWIGHT L. MOODY

JESUS SAID
HEAVEN IS A
PERFECT PLACE.
THERE WILL BE
NOTHING
UNSIGHTLY;
THERE WILL BE
NO DISCORD;
THERE WILL BE
NO
DISCREPANCIES.
IT WILL BE
PERFECT IN THE
SIGHT OF GOD.

**R. EARL
ALLEN**

A WOMAN'S DREAM

The next I knew, I was sitting in a sheltered nook, made by flowering shrubs, upon the softest and most beautiful turf of grass, thickly studded with fragrant flowers, many of them the flowers I had known and loved on earth. I remember noticing heliotrope, violets, lilies of the valley, and mignonette, with many others of like nature wholly unfamiliar to me. But even in that first moment I observed how perfect in its way was every plant and flower . . . the flowers peeped up from the deep grass, so like velvet, with sweet, happy faces, as though inviting the admiration one could not withhold.

And what a scene was that on which I looked as I rested upon this soft, fragrant cushion, secluded and yet not hidden! Away, away—far beyond the limit of my vision, I well knew—stretched this wonderful sward of perfect grass and flowers; and out of it grew equally wonderful trees, whose drooping branches were laden with exquisite blossoms and fruits of many kinds . . .

Beneath the trees, in many happy groups, were little children, laughing and playing, running hither and thither in their joy, and catching in their tiny hands the bright-winged birds that flitted in and out among them, as though sharing in their sports, as they doubtless were. All through the grounds, older people were walking,

sometimes in groups, sometimes by twos, sometimes alone, but all with an air of peacefulness and happiness that made itself felt by even me, a stranger. All were in spotless white, though many wore about them or carried in their hands clusters of beautiful flowers.

REBECCA RUTER SPRINGER
Intra Muros — "My Dream of Heaven"5

THE NEW EARTH

The hills and valleys of Heaven will be to those you now experience not as a copy is to an original, nor as a substitute is to the genuine article, but as the flower to the root, or the diamond to the coal . . . Then the new earth and sky, the same yet not the same as these, will rise in us as we have risen in Christ. And once again, after who knows what aeons of the silence and the dark, the birds will sing and the waters flow, and lights and shadows move across the hills, and the faces of our friends laugh upon us with amazed recognition. Guesses, of course, only guesses. If they are not true, something better will be.

C. S. LEWIS
Letters to Malcolm: Chiefly on Prayer

IMPERISHABLE

The city which God has prepared is as imperishable in its inhabitants as its materials. Its pearl, its jasper, its pure gold, are only immortal to frame the abode of immortals. No cry of death is in any of its dwellings. No funeral darkens along any of its ways. No sepulcher of the holiest relics gleams among the everlasting hills. "Violence is not heard in the land." "There is no more death." Its very name has perished. "Is swallowed up in victory."

RICHARD WINTER HAMILTON

THE CELESTIAL CITY

The City stood upon a mighty hill, but the Pilgrims went up that hill with ease, because they had these two men to lead them up by the arms; also they had left their mortal garments behind them in the river; for though they went in with them, they came out without them. They therefore went up here with much agility and speed though the foundation upon which the City was framed was higher than the clouds. They therefore went up through the regions of the air, sweetly talking as they went, being comforted, because they safely got over the river, and had such glorious companions to attend them.

The talk they had with the shining ones, was about the glory of the place, who told them, that the beauty, and the glory of it was inexpressible. "There," said they, "is the Mount Sion, the heavenly Jerusalem, the innumerable company of angels, and the spirits of just men made perfect. You are going now," said they, "to the Paradise of God, wherein you shall see the Tree of Life, and eat of the never-fading fruits thereof: and when you come there you shall have white robes given you, and your walk and talk shall be every day with the King, even all the days of eternity. There you shall not see again such things as you saw when you were in the lower region upon the earth, to wit, sorrow, sickness, affliction, and death, for the former things are passed

away . . .

The men then asked, "What must we do in the holy place?" To whom it was answered, "You must there receive the comfort of all your toil, and have joy for all your sorrow; you must reap what you have sown, even the fruit of all your prayers and tears, and sufferings for the King by the way. In that place you must wear crowns of gold, and enjoy the perpetual sight and visions of the Holy One, for there you shall see him as he is "

There came out also at this time to meet them several of the King's trumpeters, clothed in white and shining raiment, who with melodious noises and loud, made even the Heavens to echo with their sound. These trumpeters saluted Christian and his fellow with ten thousand welcomes from the world; and this they did with shouting, and sound of the trumpet. Now I saw in my dream, that these two men went in at the gate; and lo, as they entered, they were transfigured, and they had raiment put on that shone like gold. There was also that met them with harps and crowns, and gave to them; the harp to praise withal, and the crowns in token of honor. Then I heard in my dream that all the bells in the City rang again for joy, and that it was said unto them, "Enter ye into the joy of your Lord." I also heard the men

themselves, that they sang with a loud voice, saying, "Blessing, honor, glory, and power, be to him that sitteth upon the throne, and to the Lamb forever and ever."

Now just as the gates were opened to let in the men, I looked in after them; and behold, the City shone like the sun, the streets also were paved with gold, and in them walked many men, with crowns on their heads, palms in their hands, and golden harps to sing praises withal. There were also of them that had wings, and they answered one another without intermission, saying, "Holy, Holy, Holy, is the Lord." And after that, they shut up the gates, which when I had seen, I wished myself among them.

JOHN BUNYAN
Pilgrim's Progress

MORNING LAND

"Some day," we say, and turn our eyes
Toward the fair hills of Paradise;
Some day, some time, a sweet new rest
Shall blossom, flower-like, in each breast.
Some day, some time, our eyes shall see
The faces kept in memory;
Some day their hand shall clasp our hand,
Just over in the Morning-land —
O Morning-land! O Morning-land!

EDWARD H. PHELPS

GLORIOUS CITY

A city never built with hands, nor hoary with the years of time; a city whose inhabitants no census has numbered; a city through whose street rushes no tide of business, nor nodding hearse creeps slowly with its burden to the tomb; a city without griefs or graves, without sins or sorrows, without births or burials, without marriages or mournings; a city which glories in having Jesus for its king, angels for its guards, saints for its citizens; whose walls are salvation, and whose gates are praise.

DR. GUTHRIE

THE LORD IN HIS TEMPLE

The year King Uzziah died I saw the Lord! He was sitting on a lofty throne, and the Temple was filled with his glory. Hovering about him were mighty, six-winged seraphs. With two of their wings they covered their faces; with two others they covered their feet, and with two they flew. In a great antiphonal chorus they sang, "Holy, holy, holy is the Lord of Hosts; the whole earth is filled with his glory." Such singing it was! It shook the Temple to its foundations, and suddenly the entire sanctuary was filled with smoke.

ISAIAH 6:1-4 TLB

THE HOLY CITY

One of the seven angels carried me away in the spirit to a great and high mountain, and shewed me that great city, the holy Jerusalem, descending out of Heaven from God,

Having the glory of God: and her light was like unto a stone most precious, even a jasper stone, clear as crystal;

And had a wall great and high, and had twelve gates, and at the gates twelve angels, and names written thereon, which are the names of the twelve tribes of the children of Israel:

On the east three gates; on the north three gates; on the south three gates; and on the west three gates.

And the wall of the city had twelve foundations, and in them the names of the twelve apostles of the Lamb.

And he that talked with me had a golden reed to measure the city, and the gates thereof, and the wall thereof.

And the city lieth foursquare, and the length is as large as the breadth: and he measured the city with a reed, twelve thousand furlongs. The length and the breadth and the height of it are equal.

And he measured the wall thereof, a hundred and forty and four cubits, according to the measure of man,

that is, of the angel.

And the building of the wall of it was of jasper: the city was pure gold, like unto clear glass.

And the foundations of the wall of the city were garnished with all manner of precious stones . . .

And the twelve gates were twelve pearls; every several gate was of one pearl: and the street of the city was pure gold, as it were transparent glass.

REVELATION 21:10-19,21 KJV

O HOLY CITY

O holy city, seen of John,
Where Christ, the Lamb, doth reign,
Within whose four-square walls shall come
No night, nor need, nor pain,
And where the tears are wiped from eyes
That shall not weep again!

Hark, how from men whose lives are held
More cheap than merchandise;
From women struggling sore for bread,
From little children's cries,
There swells the sobbing human plaint
That bids thy walls arise!

O shame to us who rest content
While lust and greed for gain
In street and shop and tenement
Wring gold from human pain,
And bitter lips in blind despair
Cry, "Christ hath died in vain!"

Give us, O God, the strength to build
The city that hath stood

Too long a dream, whose laws are love,
 Whose ways are brotherhood,
And where the sun that shineth is
 God's grace for human good.

Already in the mind of God
 That city riseth fair:
Lo, how its splendor challenges
 The souls that greatly dare —
Yea, bids us seize the whole of life
 And build its glory there.

WALTER RUSSELL BOWIE

CITY NOT MADE WITH HANDS

City not made with hands,
Not throned above the skies,
Nor walled with shining walls,
Nor framed with stones of price,
More bright than gold or gem,
God's own Jerusalem!

Where'er the gentle heart
Finds courage from above;
Where'er the heart forsook
Warms with the breath of love;
Where faith bids fear depart,
City of God, thou art.

Thou art where'er the proud
In humbleness melts down;
Where self itself yields up;
Where martyrs win their crown;
Where faithful souls possess
Themselves in perfect peace;

Where in life's common ways
With cheerful feet we go;
Where in his steps we tread,
Who trod the way of woe;
Where he is in the heart,
City of God, thou art.

FRANCIS TURNER PALGRAVE

WOMAN'S DREAM

S uch a grand chorus of voices, such unity, such harmony, such volume, was never heard on earth. It rose, it swelled . . . And still, above it all, we heard the voices of the angel choir, no longer breathing the soft, sweet melody, but bursting forth into paeans of triumphant praise. A flood of glory seemed to fill the place, and looking upward we beheld the great dome ablaze with golden light, and the angelic forms of the no longer invisible choir in its midst, with their heavenly harps and viols, and their faces only less radiant than that of Him in whose praise they sang. And He, before whom all Heaven bowed in adoration, stood with uplifted face and kingly, mien, the very God of earth and Heaven. He was the center of all light, and a divine radiance surrounded Him that was beyond compare.

As the hymn of praise and adoration ceased, all sank slowly to their knees, and every head was bowed and every face covered as the angel choir chanted again the familiar words:

"Glory be to the Father, and to the Son, and to the Holy Ghost. As it was in the beginning, is now, and ever shall be, world without end. Amen, Amen!"

REBECCA RUTER SPRINGER
Intra Muros — "My Dream of Heaven"[6]

87

THE THRONE IN HEAVEN

After this I looked, and there before me was a door standing open in Heaven. And the voice I had first heard speaking to me like a trumpet said, "Come up here, and I will show you what must take place after this." At once I was in the Spirit, and there before me was a throne in Heaven with someone sitting on it. And the one who sat there had the appearance of jasper and carnelian. A rainbow, resembling an emerald, encircled the throne. Surrounding the throne were twenty-four other thrones, and seated on them were twenty-four elders. They were dressed in white and had crowns of gold on their heads. From the throne came flashes of lightning, rumblings and peals of thunder. Before the throne, seven lamps were blazing. These are the seven spirits of God. Also before the throne there was what looked like a sea of glass, clear as crystal.

In the center, around the throne, were four living creatures, and they were covered with eyes, in front and in back. The first living creature was like a lion, the second was like an ox, the third had a face like a man, the fourth was like a flying eagle. Each of the four living creatures had six wings and was covered with eyes all around, even under his wings. Day and night they never stop saying:

"Holy, holy, holy is the Lord God Almighty, who was,
and is, and is to come.

88

Whenever the living creatures give glory, honor and thanks to him who sits on the throne and who lives for ever and ever, the twenty-four elders fall down before him who sits on the throne, and worship him who lives for ever and ever. They lay their crowns before the throne and say:

"You are worthy, our Lord and God,
to receive glory and honor and power,
for you created all things,
and by your will they were created
and have their being."

REVELATION 4 NIV

STEPHEN'S GLIMPSE

B ut he [Stephen], being full of the Holy Spirit, gazed into Heaven and saw the glory of God, and Jesus standing at the right hand of God, and said, "Look! I see the Heavens opened and the Son of Man standing at the right hand of God!"

. . . And they stoned Stephen as he was calling on God and saying, "Lord Jesus, receive my spirit." Then he knelt down and cried out with a loud voice, "Lord, do not charge them with this sin." And when he had said this, he fell asleep.

ACTS 7:55-56, 59-60 NKJV

IN THE SPIRITUAL
WORLD NO ONE
IS PERMITTED TO
THINK AND WILL
IN ONE WAY AND
SPEAK AND ACT
IN ANOTHER.

EMANUEL
SWEDENBORG

EZEKIEL'S VISION

E zekiel was a priest (the son of Buzi) who lived with the Jewish exiles beside the Chebar Canal in Babylon.

One day late in June, when I was thirty years old, the heavens were suddenly opened to me and I saw visions from God. I saw, in this vision, a great storm coming toward me from the north, driving before it a huge cloud glowing with fire, with a mass of fire inside that flashed continually; and in the fire there was something that shone like polished brass.

Then from the center of the cloud, four strange forms appeared that looked like men, except that each had four faces and two pairs of wings! Their legs were like those of men, but their feet were cloven like calves' feet, and shone like burnished brass. And beneath each of their wings I could see human hands.

The four living beings were joined wing to wing, and they flew straight forward without turning. Each had the face of a man [in front], with a lion's face on the right side [of his head], and the face of an ox on his left side, and the face of an eagle at the back of his head! Each had two pairs of wings spreading out from the middle of his back. One pair stretched out to attach to the wings of the living being on each side, and the other pair covered his body. Wherever their spirit went they went, going straight

forward without turning.

Going up and down among them were other forms that glowed like bright coals of fire or brilliant torches, and it was from these the lightning flashed. The living beings darted to and fro, swift as lightning.

As I stared at all of this, I saw four wheels on the ground beneath them, one wheel belonging to each. The wheels looked as if they were made of polished amber and each wheel was constructed with a second wheel crosswise inside. They could go in any of the four directions without having to face around. The four wheels had rims and spokes and the rims were filled with eyes around their edges.

When the four living beings flew forward, the wheels moved forward with them. When they flew upwards, the wheels went up too. When the living beings stopped, the wheels stopped. For the spirit of the four living beings was in the wheels; so wherever their spirit went, the wheels and the living beings went there too.

The sky spreading out above them looked as though it were made of crystal; it was inexpressibly beautiful.

Each being's wings stretched straight out to touch the others' wings, and each had two wings covering his body. And as they flew, their wings roared like waves against the shore, or like the voice of God, or like the

shouting of a mighty army. When they stopped they let down their wings. And every time they stopped, there came a voice from the crystal sky above them.

For high in the sky above them was what looked like a throne made of beautiful blue sapphire stones, and upon it sat someone who appeared to be a Man.

From his waist up, he seemed to be all glowing bronze, dazzling like fire; and from his waist down he seemed to be entirely flame, and there was a glowing halo like a rainbow all around him. That was the way the glory of the Lord appeared to me. And when I saw it, I fell face downward on the ground.

EZEKIEL 1:1-28A TLB

THE RIVER OF LIFE

Aand he pointed out to me a river of pure Water of Life, clear as crystal, flowing from the throne of God and the Lamb, coursing down the center of the main street. On each side of the river grew Trees of Life, bearing twelve crops of fruit, with a fresh crop each month; the leaves were used for medicine to heal the nations.

There shall be nothing in the city which is evil; for the throne of God and of the Lamb will be there and his servants will worship him. And they shall see his face; and his name shall be written on their foreheads. And there will be no night there — no need for lamps or sun — for the Lord God will be their light; and they shall reign forever and ever.

REVELATION 22:1-5 TLB

A WOMAN'S DREAM

When we reached the brink of the river, but a few steps distant, I found that the lovely sward ran even to the water's edge, and in some places I saw the flowers blooming placidly down in the depths, among the many-colored pebbles with which the entire bed of the river was lined.

"I want you to see these beautiful stones," said my brother, stepping into the water and urging me to do the same.

I drew back timidly, saying, "I fear it is cold."

"Not in the least," he said, with a reassuring smile. "Come."

"Just as I am?" I said, glancing down at my lovely robe, which, to my great joy, I found was similar to those of the dwellers in that happy place.

"Just as you are," with another reassuring smile.

Thus encouraged, I, too, stepped into the "gently flowing river," and to my great surprise found the water, in both temperature and density, almost identical with the air. Deeper and deeper grew the stream as we passed on, until I felt the soft, sweet ripples playing about my throat. As I stopped, my brother said, "A little farther still."

"It will go over my head," I expostulated. "Well, and what then? I cannot breathe under the water—I will

96

suffocate."

An amused twinkle came into his eyes, though he said soberly enough, "We do not do those things here."

I realized the absurdity of my position, and with a happy laugh said, "All right; come on," and plunged headlong into the bright water, which soon bubbled and rippled several feet above my head. To my surprise and delight, I found I could not only breathe, but laugh and talk, see and hear, as naturally under the water as above it. I sat down in the midst of the many-colored pebbles, and filled my hands with them, as a child would have done. My brother lay down upon them, as he would have done on the green sward, and laughed and talked joyously with me.

"Do this," he said, rubbing his hands over his face, and running his fingers through his dark hair.

I did as he told me, and the sensation was delightful. I threw back my loose sleeves and rubbed my arms, then my throat, and again thrust my fingers through my long, loose hair, thinking at the time what a tangle it would be in when I left the water. Then the thought came, as we at last arose to return, "What are we to do for towels?" for the earth-thoughts still clung to me; and I wondered, too, if the lovely robe was not entirely spoiled. But behold, as we neared the shore and my

head once more emerged from the water, the moment the air struck my face and hair I realized that I would need no towel or brush. My flesh, my hair, and even my beautiful garments, were soft and dry as before the water touched them. The material out of which my robe was fashioned was unlike anything that I had ever seen. It was soft and light and shone with a faint luster, reminding me more of silk crepe than anything I could recall, only infinitely more beautiful. It fell about me in soft, graceful folds, which the water seemed to have rendered even more lustrous than before.

REBECCA RUTER SPRINGER
Intra Muros — "My Dream of Heaven"[7]

LIGHT PERPETUAL

No temple could be seen in the city, for the Lord God Almighty and the Lamb are worshiped in it everywhere. And the city has no need of sun or moon to light it, for the glory of God and of the Lamb illuminate it. Its light will light the nations of the earth, and the rulers of the world will come and bring their glory to it. Its gates never close; they stay open all day long—and there is no night! And the glory and honor of all the nations shall be brought into it. Nothing evil will be permitted in it—no one immoral or dishonest—but only those whose names are written in the Lamb's Book of Life.

REVELATION 21:22-27 TLB

HIERUSALEM, MY HAPPY HOME

Hierusalem, my happy home,
When shall I come to thee?
When shall my sorrows have an end,
Thy joys when shall I see?
O happy harbor of the saints,
O sweet and pleasant soil,
In thee no sorrow may be found
No grief, no care, no toil
No dampish mist is seen in thee,
No cold nor darksome night;
There every soul shines as the sun,
There God himself gives light.
There lust and lucre cannot dwell,
There envy bears no sway;
There is no hunger, heat, nor cold,
TfBut pleasure every way.
Hierusalem, Hierusalem,
God grant I once may see
Thy endless joys, and of the same
Partaker aye to be . . .

UNKNOWN

THE FURTHER UP
AND THE
FURTHER IN YOU
GO, THE BIGGER
EVERYTHING
GETS. THE INSIDE
IS LARGER THAN
THE OUTSIDE

C. S. LEWIS
THE LAST
BATTLE

THE NEWNESS OF HEAVEN

Everything is gone that ever made Jerusalem, like all cities, torn apart, dangerous, heartbreaking, seamy. You walk the streets in peace now. Small children play unattended in the parks. No stranger goes by whom you can't imagine a fast friend. The city has become what those who loved it always dreamed and what in their dreams she always was. The new Jerusalem. That seems to be the secret of Heaven. The new Chicago, Leningrad, Hiroshima, Beirut. The new bus driver, hot-dog man, seamstress, hairdresser. The new you, me, everybody. It was always buried there like treasure in all of us — the best we had it in us to become — and there were times you could almost see it. Even the least likely face, asleep, bore traces of it. Even the bombed-out city after nightfall with the public squares in a shambles and moonlight glazing the broken pavement. To speak of heavenly music or a heavenly day isn't always to gush but sometimes to catch a glimpse of something. "Death shall be no more, neither shall there be mourning nor crying nor pain anymore," the Book of Revelation says. You can catch a glimpse of that too in almost anybody's eyes if you choose the right moment to look, even in animals' eyes.

If the new is to be born, though, the old has to die. It is the law of the place. For the best to happen, the worst

must stop happening—the worst we are, the worst we do. But maybe it isn't as difficult as it sounds. It was a hardened criminal within minutes of death, after all, who said only, "Jesus, remember me," and that turned out to be enough. "This day you will be with me in Paradise" was the answer he just managed to hear.

FREDERICK BUECHNER
Eternally Long Life

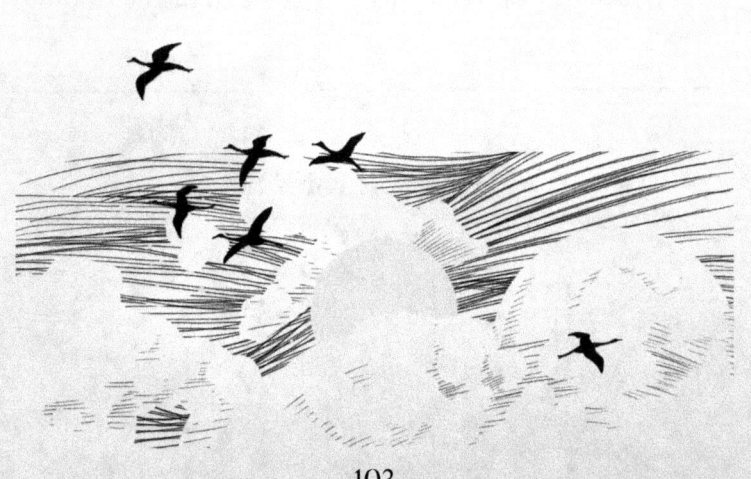

FOREVER ... AND EVER

Suppose the whole world were a sea, and that, when every thousand years expired, a bird must carry away or drink up only one drop of it. In process of time, it will come to pass that this sea, though very huge, shall be dried up; but yet many thousand millions of years must pass before this can be done. Now, if a man should enjoy happiness in Heaven only for the space of time in which the sea is drying up, he would think his case most happy and blessed: but, behold! the elect shall enjoy the kingdom of Heaven not only for that time, but when it is ended, they shall enjoy it as long again: and when all is done, they shall be as far from ending this their joy as they were in the beginning.

W. PERKINS

ETERNALLY LONG LIFE

With long life will I satisfy him.
PSALM 91:16

I get a good deal of comfort out of that promise. I don't think that means a short life down here, seventy years, eighty years, ninety years, or one hundred years. Do you think that any man living would be satisfied if they could live to be one hundred years old and then have to die? Not by a good deal. Suppose Adam had lived until today and had to die to night, would he be satisfied? Not a bit of it! Not if he had lived a million years, and then had to die.

You know we are all the time coming to the end of things here — the end of the week, the end of the month, the end of the year, the end of school days. It is end, end, end all the time. But, thank God, He is going to satisfy us with long life; no end to it, an endless life.

DWIGHT L. MOODY

JESUS IS THE
ATTRACTION

W e'll see Him by and by. It is not the jasper streets and golden gates that attract us to Heaven. What are your golden palaces on earth—what is it that makes them so sweet? It is the presence of some loving wife or fond children. Let them be taken away and the charm of your home is gone. And so it is Christ that is the charm of Heaven to the Christian. Yes, we shall see Him there. How sweet the thought that we shall dwell with Him forever, and shall see the nails in His hands and in His feet which He received for us . . . So it is not Heaven that is alone attractive to us; it is the knowledge that Jesus, our leader, our brother, our Lord, is there.

And the spirits of loved ones, whose bodies we have laid in the earth, will be there. We shall be in good company there. When we reach that land we shall meet all the Christians who have gone before us. We are told in Matthew, too, that we shall meet angels there: "Take heed lest ye despise not one of these little ones, for I say unto you that in Heaven their angels do always behold the face of my Father which is in Heaven" Yes, the angels are there, and we shall see them when we get home.

He is there, and where He is, His disciples shall be, for He has said: "I go to prepare a place for you, that where I am there ye may be also." I believe that when we die the

spirit leaves the body and goes to the mansion above, and by and by the body will be resurrected and it shall see Jesus. Very often people come to me and say: "Mr. Moody, do you think we shall know each other in Heaven?" Very often it is a mother who has lost a dear child, and who wishes to see it again. Sometimes it is a child who has lost a mother, a father, and who wants to recognize them in Heaven. There is just one verse in Scripture in answer to this, and that is: "We shall be satisfied." It is all I want to know. My brother who went up there the other day I shall see, because I will be satisfied. We will see all those we loved on earth up there, and if we loved them here we will love them ten thousand times more when we meet them there.

DWIGHT L. MOODY

OUR HEAVENLY BODIES

Beloved, we are God's children now, it does not yet appear what we shall be, but we know that when he appears we shall be like him, for we shall see him as he is.

1 JOHN 3:2 RSV

This excellency of our Heavenly bodies will probably arise, in great measure from the happiness of our souls. The unspeakable joy that we then shall feel will break through our bodies, and shine forth in our countenances; as the joy of the soul, even in this life, has some influence upon the countenance, by rendering it more open and cheerful, so Solomon tells us, "A man's wisdom makes his face to shine." Virtue, as it refines a man's heart, so it makes his very looks more cheerful and lively.

Our bodies shall be raised in power. This expressed the sprightliness of our heavenly bodies, the nimbleness of their motion, by which they shall be obedient and able instruments of the soul. In this state, our bodies are no better than clogs and fetters, which confine and restrain the freedom of the soul. The corruptible body presses down the soul, and the earthly tabernacle weighs down the mind. Our dull, sluggish, inactive

bodies are often unable, or too backward, to obey the commands of the soul. But in the other life, "they that wait upon the Lord shall renew their strength; they shall mount up with wings as eagles; they shall run, and not be weary: they shall walk, and not faint". Or, as another expresses it, "they shall run to and fro like sparks among the stubble." The speed of their motion shall be like that of devouring fire in stubble; and the height of it, above the towering of an eagle; for they shall meet the Lord in the air when he comes to judgment, and mount up with him into the highest Heaven. This earthly body is slow and heavy in all its motions, listless and soon tired with action. But our heavenly bodies shall be as fire; as active and as nimble as our thoughts are.

JOHN WESLEY

109

PRECIOUS FOUNDATION

The foundations of the wall of the city were adorned with all kinds of precious stones:

the first foundation was jasper,
the second sapphire,
the third chalcedony,
the fourth emerald,
the fifth sardonyx,
the sixth sardius,
the seventh chrysolite,
the eighth beryl,
the ninth topaz,
the tenth chrysoprase,
the eleventh jacinth,
and the twelfth amethyst.

REVELATION 21:19,20 NKJV

HEAVENLY SUNSHINE, HEAVENLY SUNSHINE! FLOODING MY SOUL WITH GLORY DIVINE! HEAVENLY SUNSHINE, HEAVENLY SUNSHINE! HALLELUJAH, JESUS IS MINE!

CHARLES E. FULLER

PARADISE DIVINE

There is a land where everlasting suns shed everlasting brightness; where the soul drinks from the living streams of love that roll by God's high throne! — myriads of glorious ones bring their accepted offering. Oh! how blest to look from this dark prison to that shrine, to inhale one breath of Paradise divine, and enter into that eternal rest which waits the sons of God!

SIR JOHN BOWRING

BEYOND THE SUNSET

...The gate shall not be shut until the evening
EZEKIEL 46:2

Do you say that the best is behind us?
Is it true that life's beauty is gone?
Is it sad that the morning is over —
That the twilight is gathering on?

When you turn from the flowers and sunshine,
And you walk with your face to the shade,
And you think of the gladness departed —
Is it true that your heart is afraid?

O I say that the best is before us!
We have not yet dreamed of the best —
Of the beautiful days that are coming,
Though our pathway winds down to the West.

It is farther away from the sunset;
It is past all the hush of the night;
When the sleep and the silence are over,
We shall open our eyes to the light.

EDITH HICHMAN DIVALL

EVERLASTING FELICITY

How great shall be that felicity, which shall be tainted with no evil, which shall lack no good, and which shall afford leisure for the praises of God, who shall be all in all! For I know not what other employment there can be where no lassitude shall slacken activity, nor any want stimulate to labor. I am admonished also by the sacred song, in which I read or hear the words, "Blessed are they that dwell in Thy house, O Lord; they will be still praising Thee." All the members and organs of the incorruptible body, which now we see to be suited to various necessary uses, shall contribute to the praises of God; for in that life necessity shall have no place, but full, certain, secure, everlasting felicity . . .

What power of movement such bodies shall possess, I have not the audacity rashly to define, as I have not the ability to conceive. Nevertheless I will say that in any case, both in motion and at rest, they shall be, as in their appearance, seemly; for into that state nothing which is unseemly shall be admitted. One thing is certain, the body shall forthwith be wherever the spirit wills, and the spirit shall will nothing which is unbecoming either to the spirit or to the body.

True honor shall be there, for it shall be denied to none who is worthy, nor yielded to any unworthy;

neither shall any unworthy person so much as sue for it, for none but the worthy shall be there. True peace shall be there, where no one shall suffer opposition either from himself or any other. God Himself, who is the Author of virtue, shall there be its reward; for, as there is nothing greater or better, He has promised Himself. What else was meant by His word through the prophet, "I will be your God, and ye shall be my people," then, I shall be their satisfaction, I shall be all that men honorably desire—life, and health, and nourishment, and plenty, and glory, and honor, and peace, and all good things? This, too, is the right interpretation of the saying of the apostle, "That God may be all in all." He shall be the end of our desires who shall be seen without end, loved without cloy, praised without weariness. This outgoing of affection, this employment, shall certainly be, like eternal life itself, common to all.

AUGUSTINE
The City of God

BUS RIDE TO HEAVEN

The light and coolness that drenched me were like those of summer morning, early morning a minute or two before the sunrise, only that there was a certain difference. I had the sense of being in a larger space, perhaps even a larger sort of space, than I had ever known before: as if the sky were further off and the extent of the green plain wider than they could be on this little ball of earth. I had got "out" in some sense which made the Solar System itself seem an indoor affair . . .

It was the light, the grass, the trees that were different; made of some different substance, so much soldier than things in our country that men were ghosts by comparison. Moved by a sudden thought, I bent down and tried to pluck a daisy which was growing at my feet. The stalk wouldn't break. I tried to twist it, but it wouldn't twist. I tugged till the sweat stood out on my forehead and I had lost most of the skin off my hands. The little flower was hard, not like wood or even like iron, but like diamond. There was a leaf — young tender beech-leaf, lying in the grass beside it. I tried to pick the leaf up: my heart almost cracked with the effort, and I believe I did just raise it. But I had to let it go at once; it was heavier than a sack of coal. As I stood, recovering my breath with great gasps and looking down at the

daisy, I noticed that I could see the grass not only between my feet but through them. I also was a phantom. Who will give me words to express the terror of that discovery? "Golly!" thought I. "I'm in for it this time."

C. S. LEWIS
The Great Divorce

YOUR PORTION IN HEAVEN

Doubting one, thou hast often said, "I fear I shall never enter Heaven." Fear not; all the people of God shall enter there; there is no fear about it. I love the quaint saying of a dying man, who, in his country brogue exclaimed, "I have no fear of going home; I have sent all before me; God's finger is on the latch of my door and I am ready for him to enter."

"But," said one, "Are you not afraid lest you should miss your inheritance?"

"Nay," said he, "nay; there is one crown in Heaven that the angel Gabriel could not wear; it will fit no head but mine. There is one throne in Heaven that Paul the Apostle could not fill; it was made for me, and I shall have it. There is one dish at the banquet that I must eat, or else it will be untasted, for God has set it apart for me." O Christian, what a joyous thought! thy portion is secure; "there remaineth a rest."

"But cannot I forfeit it?" No; it is entailed. If I be a child of God I shall not lose it. It is mine as securely as if I were there.

C. H. SPURGEON

LOVE RULES
THE CAMP,
THE COURT,
THE GROVE —
FOR LOVE IS
HEAVEN
AND HEAVEN IS
LOVE.

LORD BYRON

ETERNAL

Heaven's the perfection of all that can be said or thought — riches, delight, harmony, health, beauty; and all these not subject to the waste of time, but in their height eternal.

JAMES SHIRLEY

Before the sun has climbed above the horizon, all objects on earth are blended in one common indistinct gray hue: you can just discern their difference of form. The sun rises, color appears, outlines define themselves, variety and time are born at once. Before, there was only a dull monotony; now, there is harmony. The life to come has a similar marvel in reserve. At the first ray of its light, our true characters, purified, but preserving their identity, will more fully expand; and the result of the infinite diversity will be a complete unity.

MADAME DE GASPARIN

A WOMAN'S DREAM

Delightful surprises met me at every turn. Now a dear friend, from whom I had parted years ago in the earth-life, would come unexpectedly upon me with cordial greeting; now one— perhaps on earth greatly admired, but from whom I had held aloof, from the fear of unwelcome intrusion—would approach me, showing the lovely soul so full of responsive kindness and congenial thought, that I could but feel a pang of regret for what I had lost. Then the clear revelation of some truth, only partly understood in life, though eagerly sought for, would stand out clear and strong before me, overwhelming me with its luster, and perhaps showing the close tie linking the earth-life with the divine. But the most wonderful to me was the occasional meeting with someone whom I had never hoped to meet "over there," who, with eager handclasp and tearful eyes, would pour forth his earnest thanks for some helpful word, some solemn warning, or even some stern rebuke, that had turned him, all unknown to myself, from the paths of sin into the "life everlasting." Oh, the joy to me of such a revelation! Oh, the regret that my earth-life had not been more frill of such work for eternity!

REBECCA RUTER SPRINGER
Intra Muros -— "My Dream of Heaven"s

121

MULTITUDE OF DEAR ONES

With how joyous a breast the heavenly city receives those that return from flight! How happily she meets them that bear the trophies of the conquered enemy! And with triumphant men, women also come, who rose superior both to this world, and to their sex, doubling the glory of their welfare; virgins with youths, who surpassed their tender years by their virtues. Yet not they alone, but the rest of the multitude of the faithful shall also enter the palace of that eternal court, who in peaceful union have observed the heavenly commandments, and have maintained the purity of the faith.

But above all these things is the being associated with the companies of angels and archangels, throne and dominations, principalities and powers, and the enjoyment of the watches of all the celestial virtues — to behold the squadron of the saints, adorned with stars; the patriarchs, glittering with faith; the prophets, rejoicing in hope; the apostle, who in the twelve tribes of Israel, shall judge the whole world; the martyrs, decked with the purple diadems of victory; the virgins, also, with their wreaths of beauty. But of the King, who is in the midst, no words are able to speak. That beauty, that virtue, that glory, that magnificence, that majesty, surpasses every expression, every sense of the human mind. For it is greater than the glory of all saints; but to

attain to that ineffable sight, and to be made radiant with the splendor of His countenance, it was worthwhile to suffer torment every day—it was worthwhile to endure hell itself for a season, so that we might behold Christ coming in glory, and be joined to the number of the saints; so is it not then well worthwhile to endure earthly sorrows, that we may be partakers of such good, and of such glory?

What, beloved brethren, will be the glory of the righteous; what that great gladness of the saints, when every face shall shine as the sun; when the Lord shall begin to count over in distinct orders His people, and to receive them into the kingdom of His Father, and to render to each the rewards promised to their merits and to their works—things heavenly for things earthly, things eternal for things temporal, a great reward for a little labor; to introduce the saints to the vision of His Father's glory; and "to make them sit down in heavenly places," to the end that God may be all in all; and to bestow on them that love Him that eternity which He has promised to them—that immortality for which He has redeemed them by the quickening of His own blood; lastly, to restore them to Paradise, and to open the kingdom of Heaven by the faith and verity of His promise!

. . . A great multitude of dear ones is there expecting us; a vast and mighty crowd of parents, brothers, and children, secure now of their own safety, anxious yet for our salvation, long that we may come to their right and embrace them, to that joy which will be common to us and to them, to that pleasure expected by our fellow servants as well as ourselves, to that full and perpetual felicity . . . If it be a pleasure to go to them, let us eagerly and covetously hasten on our way, that we may soon be with them, and soon be with Christ; that we may have Him as our Guide in this journey, who is the Author of Salvation, the Prince of Life, the Giver of Gladness, and who liveth and reigneth with God the Father Almighty and with the Holy Ghost.

ST. BEDE
from a sermon preached on "All Saint's Day" about 710

AT HOME WITH OUR LOVED ONES

If there is anything that ought to make Heaven near to Christians, it is knowing that God and all their loved ones will be there. What is it that makes home so attractive? Is it because we have a beautiful home? Is it because we have beautiful lawns? Is it because we have beautiful trees around us? Is it because we have beautiful paintings upon the walls inside? Is it because we have beautiful furniture? Is that all that makes home so attractive and beautiful? Nay, it is the loved ones in it; it is the loved ones there.

I remember after being away from home some time, I went back to see my honored mother, and I thought in going back I would take her by surprise, and steal in unexpectedly upon her, but when I found she had gone away, the old place didn't seem like home at all. I went into one room and then into another, and all through the house, but I could not find that loved mother, and I asked some member of the family, "Where is mother?" and they said she had gone away. Well, home had lost its charm to me; it was that mother who made home so sweet to me, and it is the loved ones who make home so sweet to everyone; it is the presence of the loved ones that will make Heaven so sweet to all of us. Christ is there; God the Father, is there; and many, many who were dear to us when they lived on earth are there—and we shall be with them by and by.

DWIGHT L. MOODY

FULL RECOGNITION

I t may very well be, and it is thoroughly credible, that we shall in the future world see the material forms of the new heavens and the new earth in such a way that we shall most distinctly recognize God everywhere present and governing all things, material as well as spiritual, and shall see Him, not as now we understand the invisible things of God, by the things which are made, and see Him darkly, as in a mirror, and in part, and rather by faith than by bodily vision of material appearances, but by means of the bodies we shall wear and which we shall see wherever we turn our eyes.

ST. AUGUSTINE
City of God

OUR EMPLOYMENT IN HEAVEN

We are not told the exact nature of our employment in Heaven. The material universe, as we have noted, even down to the smallest electron, is in motion. Heaven undoubtedly is a very active place. Suns and planets are speeding through the universe at terrific speeds. Nothing could be further from the truth than the old idea that in Heaven the people are just sitting around, or lolling about, with nothing to do — an idle, stagnant life. It is inconsistent to imagine a Heaven in which the saints would sit under the shade of the trees, or on the bank of the River of Life, twang a harp — "perhaps a thousand strings" — and spend an eternity in a do-nothing world! . . .

We cannot conceive that God would put us in another world with renewed and enlarged powers of body and mind, and leave us with nothing to do.

LEEWIN B. WILLIAMS

TO EACH AN INHERITANCE

No spot of sin or sorrow there; all pollution wiped away, and all tears with it; no envy or strife; not as here among men, one supplanting another, one pleading and fighting against another, dividing this point of earth with fire and sword—no, this inheritance is not the less by division, by being parted among so many brethren; everyone hath it all, each his crown, and all agreeing on casting them down before His throne from whom they have received them, and in the harmony of His praises.

ROBERT LEIGHTON

GOD AT THE CENTER

On earth we tend to think of ourselves. But in Heaven things will be different. We will experience the truth of the catechism, "Man's chief end is to glorify God, and to enjoy him forever." In Heaven God, not man, will be at the center of everything. And His glory will be dominant.

Have you ever watched young couples in love communicate without words? Have you been in love yourself? People deeply in love find absolute bliss in each other's presence and wish their moments together would go on forever. If those moments could be frozen, with no sense of passing time, would that be "Heaven" for them? Have you ever said, "I wish this moment could last forever"?

I suspect those feelings are a small indication of what it would be like, frozen in time and loving God, enjoying Him, forever. We will never come down from that "mountaintop" experience.

BILLY GRAHAM

ONLY ONE
CONTENTION

A minister once asked his Sunday school children, if there should be any such thing as contention in Heaven, what they thought it would be about.

"O sir!" they replied, "there will be no strife there."

"Well, but supposing there should be such a thing: what do you think it would be about?"

"Well, sir," said one, "I suppose, if there be any contention, it will be who shall get nearest to Jesus Christ."

UNKNOWN

HOME OF GOD'S SELECT

O sweet and blessed country,
The home of God's elect!
O sweet and blessed country
That eager hearts expect!
There stand those halls of Zion
All jubilant with song,
And bright with many an angel,
And all the martyr throng.

ST. BERNARD OF CLUNY

HIS PILGRIMAGE

Give me my scallop-shell of quiet,
My staff of faith to walk upon,
My scrip of joy, immortal diet,
My bottle of salvation,
My gown of glory, hope's true gauge;
And thus I'll take my pilgrimage.

Blood must be my body's balmer,
No other balm will there be given;
Whilst my soul, like quiet palmer,
Travelleth toward the land of Heaven;
Over the silver mountains,
Where spring the nectar fountains;
There will I kiss
The bowl of bliss,
And drink mine everlasting fill
Upon every milken hill.
My soul will be a-dry before,
But after, it will thirst no more

From thence to Heaven's bribeless hall,
Where no corrupted voices brawl,
No conscience molten into gold,
No forged accuser bought or sold,

No cause deferred, no rain-spent journey;
For there Christ is the King's Attorney,
Who pleads for all without degrees,
And He hath angels, but no fees;
And when the grand twelve-million jury
Of our sins, with direful fury,
Against our souls black verdicts give,
Christ pleads His death, and then we live.

SIR WALTER RALEIGH

OPENING THE DAWN

I feel within me that future life. I am like a forest that has been razed; the new shoots are stronger and brighter. I shall most certainly rise toward the heavens . . . the nearer my approach to the end, the plainer is the sound of immortal symphonies of worlds which invite me. For half a century I have been translating my thoughts into prose and verse: history, philosophy, drama, romance, tradition, satire, ode, and song; all of these I have tried. But I feel I haven't given utterance to the thousandth part of what lies with me. When I go to the grave I can say, as others have said, "My day's work is done." But I cannot say, "My life is done." My work will recommence the next morning. The tomb is not a blind alley; it is a thoroughfare. It closes upon the twilight but opens upon the dawn.

VICTOR HUGO

HEAVEN AT THE END OF TIME

Jesus said:

"When the Son of Man comes in his glory, and all the angels with him, he will sit on his throne in heavenly glory. All the nations will be gathered before him, and he will separate the people one from another as a shepherd separates the sheep from the goats. He will put the sheep on his right and the goats on his left.

"Then the King will say to those on his right, 'Come, you who are blessed by my Father; take your inheritance, the kingdom prepared for you since the creation of the world. For I was hungry and you gave me something to eat, I was thirsty and you gave me something to drink, I was a stranger and you invited me in, I needed clothes and you clothed me, I was sick and you looked after me, I was in prison and you came to visit me.'

"Then the righteous will answer him, 'Lord, when did we see you hungry and feed you, or thirsty and give you something to drink? When did we see you a stranger and invite you in, or needing clothes and clothe you? When did we see you sick or in prison and go to visit you?'

"The King will reply, 'I tell you the truth, whatever you did for one of the least of these brothers of mine, you did for me.'

"Then they will go . . . the righteous to eternal life."

MATTHEW 25:31-40, 46 NIV

RADIANCE

There is this difference between the Sun of righteousness and that in the sky—that whereas the latter, by His presence, eclipses all the planets (His attendants), the former, though radiant with a much brighter splendor, will by His presence impart glory to His saints, according to that word, "When Christ, who is our life, shall appear, then shall ye also appear with him in glory." So that the elect, in relation to this Sun, shall not be like stars, which his shining obscures, and makes to disappear, out like polished silver, or well-glazed arms, or those vaster balls of burnished brass the tops of churches are sometimes adorned with, which shine not till they are shined upon, and derive their glittering brightness, and all the dazzling fire that environs and illustrates them, from their being exposed (unscreened) to the sun's refulgent beams.

R. BOYLE

EARTH HAS
NO SORROW
THAT HEAVEN
CANNOT HEAL

**THOMAS
MOORE**

HEAVEN FOR THOSE WHO ENDURE

I saw a vast crowd, too great to count, from all nations and provinces and languages, standing in front of the throne and before the Lamb, clothed in white, with palm branches in their hands. And they were shouting with a mighty shout, "Salvation comes from our God upon the throne, and from the Lamb."

And now all the angels were crowding around the throne and around the Elders and the four Living Beings, and falling face down before the throne and worshiping God. "Amen!" they said. "Blessing, and glory, and wisdom, and thanksgiving, and honor, and power, and might, be to our God forever and forever. Amen!"

Then one of the twenty-four Elders asked me, "Do you know who these are, who are clothed in white, and where they come from?"

"No, sir," I replied. "Please tell me."

"These are the ones coming out of the Great Tribulation," he said; "they washed their robes and whitened them by the blood of the Lamb. That is why they are here before the throne of God, serving him day and night in his temple. The one sitting on the throne will shelter them; they will never be hungry again, nor thirsty, and they will be fully protected from the scorching noontime heat. For the Lamb standing in front of the throne will feed them and be their Shepherd and lead them to the springs of the Water of Life. And God will wipe their tears away."

REVELATION 7:9-17 TLB

138

LOOKING OVER

We've got some difficult days ahead. But it really doesn't matter with me now. Because I've been to the mountaintop, I won't mind. Like anybody, I would like to live a long life. Longevity has its place. But I'm not concerned about that now. I just want to do God's will.

And He's allowed me to go up to the mountain. And I've looked over, and I've seen the Promised Land. I may not get there with you, but I want you to know tonight that we as a people will get to the Promised Land.

So I'm happy tonight. I'm not worried about anything. I'm not fearing any man. "Mine eyes have seen the glory of the coming of the Lord."

MARTIN LUTHER KING, JR.

RISE IN GLORY

When we rise again with glorious bodies, in the power of the Lord, these bodies will be white and resplendent as the snow, more brilliant than the sun, more transparent than crystal, and each one will have a special mark of honor and glory, according to the support and endurance of torments and sufferings, willingly and freely borne to the honor of God.

JAN VAN RUYSBROECK

THE WEDDING SUPPER OF THE LAMB

Then I heard what sounded like a great multitude, like the roar of rushing waters and like loud peals of thunder, shouting:

"Hallelujah!
For our Lord God Almighty reigns.
Let us rejoice and be glad and give him glory!
For the wedding of the Lamb has come,
and his bride has made herself ready.
Fine linen, bright and clean,
was given her to wear."

(Fine linen stands for the righteous acts of the saints.)

Then the angel said to me, "Write: 'Blessed are those who are invited to the wedding supper of the Lamb!' " And he added, "These are the true words of God."

REVELATION 19:6-9 NIV

THE RETURN OF CHRIST

I saw Heaven opened and a white horse standing there; and the one sitting on the horse was named "Faithful and True"—the one who justly punishes and makes war. His eyes were like flames, and on his head were many crowns. A name was written on his forehead, and only he knew its meaning. He was clothed with garments dipped in blood, and his title was "The Word of God." The armies of Heaven, dressed in finest linen, white and clean, followed him on white horses.

In his mouth he held a sharp sword to strike down the nations; he ruled them with an iron grip; and he trod the winepress of the fierceness of the wrath of Almighty God. On his robe and thigh were written this title: "King of Kings and Lord of Lords."

REVELATION 19:11-16 TLB

THE GREAT JUDGEMENT

I saw a great white throne and Him who sat on it, from whose face the earth and the Heaven fled away. And there was found no place for them.

And I saw the dead, small and great, standing before God, and books were opened. And another book was opened, which is the Book of Life. And the dead were judged according to their works, by the things which were written in the books.

The sea gave up the dead who were in it, and Death and Hades delivered up the dead who were in them. And they were judged, each one according to his works.

REVELATION 20:11-13 NKJV

REST FROM OUR LABORS

I am Resurrection and I am Life, says the Lord.
Whoever has faith in me shall have life,
even though he die.
And everyone who has life,
and has committed himself to me in faith,
shall not die forever.

As for me, I know that my Redeemer lives
and that at the last he will stand upon the earth.
After my awaking, he will raise me up;
and in my body, I shall see God.
I myself shall see, and my eyes behold him
who is my friend and not a stranger.

For none of us has life in himself,
and none becomes his own master when he dies.
For if we have life, we are alive in the Lord
and if we die, we die in the Lord.
So, then, whether we live or die,
we are the Lord's possession.

Happy from now on
are those who die in the Lord!
So it is, says the Spirit,
for they rest from their labors.

**OPENING ANTHEM FOR
THE BURIAL OF THE DEAD**
The Book of Common Prayer

THE ASSURED HOPE

As the soldier meditates upon the glory of his victories; the sick passenger at sea upon his sweet refreshings on shore; the traveler upon his journey's end and comforts at his home; the laborer and hireling on his wages; the husbandman on his harvest; the merchant on his gain; the woman in travail on her fruit, so let us sometimes warm and revive our cold hearts and fainting spirits with the assured hope of those victories, those crowns, those harvests, those refreshings and fruits, which never eye hath seen, nor ear hath heard, nor never entered into man's heart the things which God hath prepared for them that love him. Of which, however, it pleaseth God to give his servants a taste in this life, yet the harvest and the vintage are to come when they that suffer with Christ Jesus shall reign with Him, when they that have sown in tears shall reap the never-ending harvest of inconceivable joys.

ROGER WILLIAMS[9]

I SHALL RISE

I shall rise from the dead, from the prostration, from the prostration of death, and never miss the sun, which shall be put out, for I shall see the Son of God, the Sun of Glory, and shine myself as that sun shines. I shall rise from the grave, and never miss this city, which shall be nowhere, for I shall see the city of God, the new Jerusalem. I shall look up and never wonder when it shall be day, for the angel will tell me that time shall be no more, and I shall see and see cheerfully that last day of judgment, which shall have no night, never end, and be united to the Ancient of Days, to God Himself, who had no morning, never began.

JOHN DONNE

FULLY OURSELVES

God will give Himself to us, to each and to all. The human community will not break up in eternal life. In the Father's house and in Christ glorified men will be more closely united. God always wants unity among men, but in eternity this union will be consummated. We will no longer be strangers to one another, and every relation that is different from love will disappear. God will be all in everyone, and on that account, all of us will be fully ourselves, individually and for others.

PETER SCHOONENBERG, S. J.[10]

WITH CHRIST

Then one of the criminals who were hanged blasphemed Him, saying, "If You are the Christ, save Yourself and us."

But the other, answering, rebuked him, saying, "Do you not even fear God, seeing you are under the same condemnation? And we indeed justly, for we receive the due reward of our deeds; but this Man has done nothing wrong." Then he said to Jesus, "Lord, remember me when You come into Your kingdom."

And Jesus said, to him, "Assuredly, I say to you, today you will be with Me in Paradise."

LUKE 23:39-43 NKJV

NOT ALL THE
ARCHANGELS
CAN TELL
THE JOYS OF THAT
HOLIEST PLACE,
WHERE THE
FATHER
IS PLEASED TO
REVEAL
THE LIGHT OF HIS
HEAVENLY FACE.

CHARLES
WESLEY

BEULAH LAND

I've reached the land of corn and wine,
And all its riches freely mine;
Here shines undimmed one blissful day,
For all my night has passed away.

My Savior comes and walks with me,
And sweet communion here have we;
He gently leads me by the hand,
For this is Heaven's borderland.

A sweet perfume upon the breeze
Is borne from ever vernal trees,
And flow'rs, that never fading grow,
Where streams of life forever flow.

The zephyrs seem to float to me,
Sweet sounds of Heaven's melody.
As angels with the white-robed throng
Join in the sweet Redemption song.

Beulah Land, sweet Beulah Land.
As on thy highest mount I stand,
look away across the sea,
Where mansions are prepared for me,
And view the shining glory-shore,
My heav'n, my home forevermore!

EDGAR PAGE

IF GOD HATH
MADE THIS
WORLD SO FAIR,
WHERE SIN AND
DEATH ABOUND,
HOW BEAUTIFUL,
BEYOND
COMPARE, WILL
PARADISE BE
FOUND

ROBERT
MONTGOMERY

MANY MANSIONS

Jesus taught:

L et not your heart be troubled: ye believe in God, believe also in me.
In my Father's house are many mansions: if it were not so, I would have told you. I go to prepare a place for you.

And if I go and prepare a place for you, I will come again, and receive you unto myself; that where I am, there ye may be also.

JOHN 14:1-3 KJV

ENDNOTES

1, 5, 6, 7, 8, 11 - Rebecca Springer's book, Intra Muros — *"My Dream of Heaven,"* is a message that she claims came to her during a period of great physical suffering. She had been gravely ill for many weeks, and had taken no nourishment of any kind for nearly three weeks, "scarcely even water." She was greatly reduced in strength and, she says "consciousness seemed at times to wholly desert me." During this time of illness, she experienced what she has called a great peace, and a dream of Heaven. She makes no claim that she actually went to Heaven or that she had an out-of-body or near-death experience. She says, "I have never claimed that this strange experience is either a revelation or an inspiration . . . Be this as it may, it has been a great comfort and help to me." She writes at the close of her book, "I can only reiterate that I am no prophet, I am no seer; but, in my inmost soul, I honestly believe that if the joys of Heaven are greater, if the glories 'Within the Walls' are more radiant than I in my vision beheld them, I cannot understand how even the immortal spirit can bear to look upon them."

2, 4, 10 - "God's World in the Making" by Peter Schoonenberg, S.J. was published by Duquesne University Press, 1964.

3, 9 - From *Voices in the Heart*, a collection of inspirational writings.